NORMAN ROCKWELL

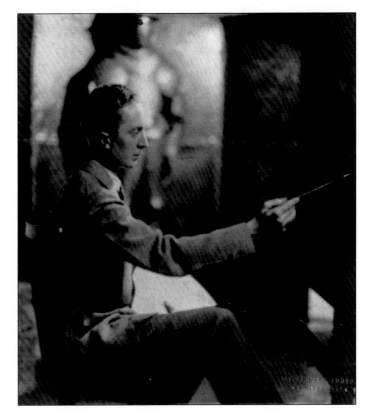

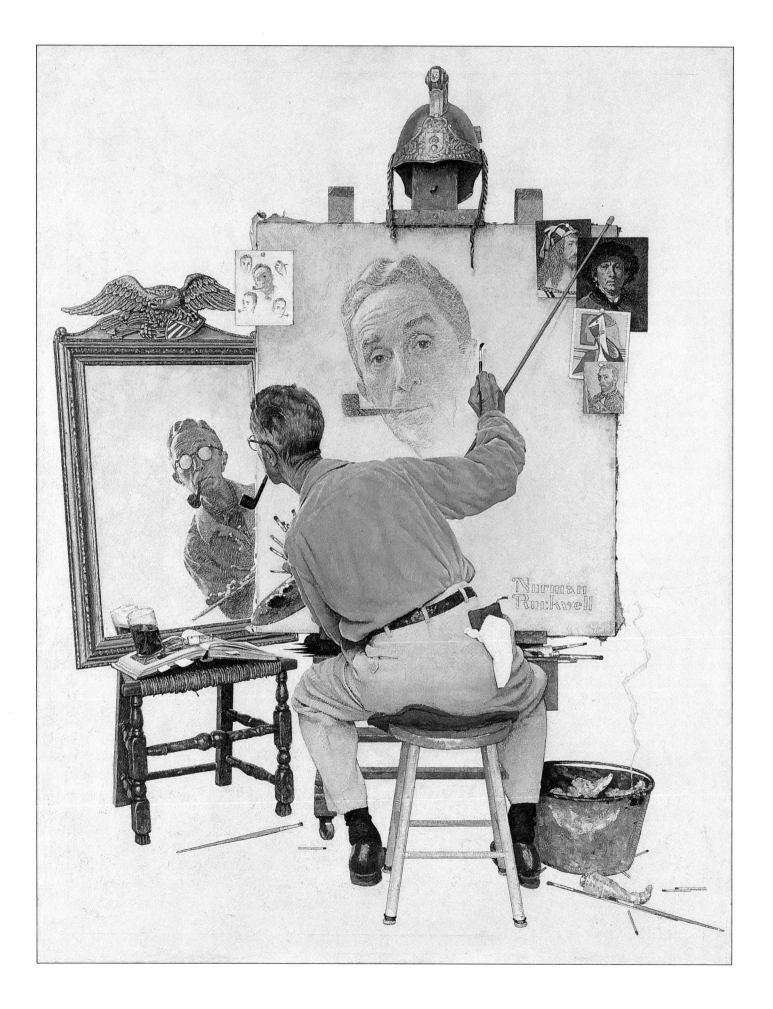

NORMAN
ROCKWELL

THE ARTIST AND HIS WORK

The Norman Rockwell Museum at Stockbridge

MetroBooks

MetroBooks

An Imprint of Friedman/Fairfax Publishers

©1999 by Michael Friedman Publishing Group, Inc.

Library of Congress Cataloging-in-Publication Data available upon request.

ISBN 1-56799-760-0

Editor: Dana Rosen
Art Director: Jeff Batzli
Designer: Kevin Ullrich
Photography Director: Christopher C. Bain

Originally published as
Norman Rockwell: A Centennial Celebration.

Printed in China by Leefung-Asco Printers Ltd.

1 3 5 7 9 10 8 6 4 2

For bulk purchases and special sales, please contact:
Friedman/Fairfax Publishers
Attention: Sales Department
15 West 26th Street
New York, NY 10010
212/685-6610 FAX 212/685-1307

Visit our website:
http://www.metrobooks.com

The museum thanks the following people for their contributions to this book: Marnie Boardman and Linda Szekely, who selected images of Rockwell artwork and of the illustrator himself; Kim Conley, June Preisser, and Janet Silverman Tobin for their work on the text; Carol Raymond for her assistance with editing; Joanne Dunn, who helped get the project off the ground; and Tom Rockwell, who provided guidance, corrections, and helpful insights.

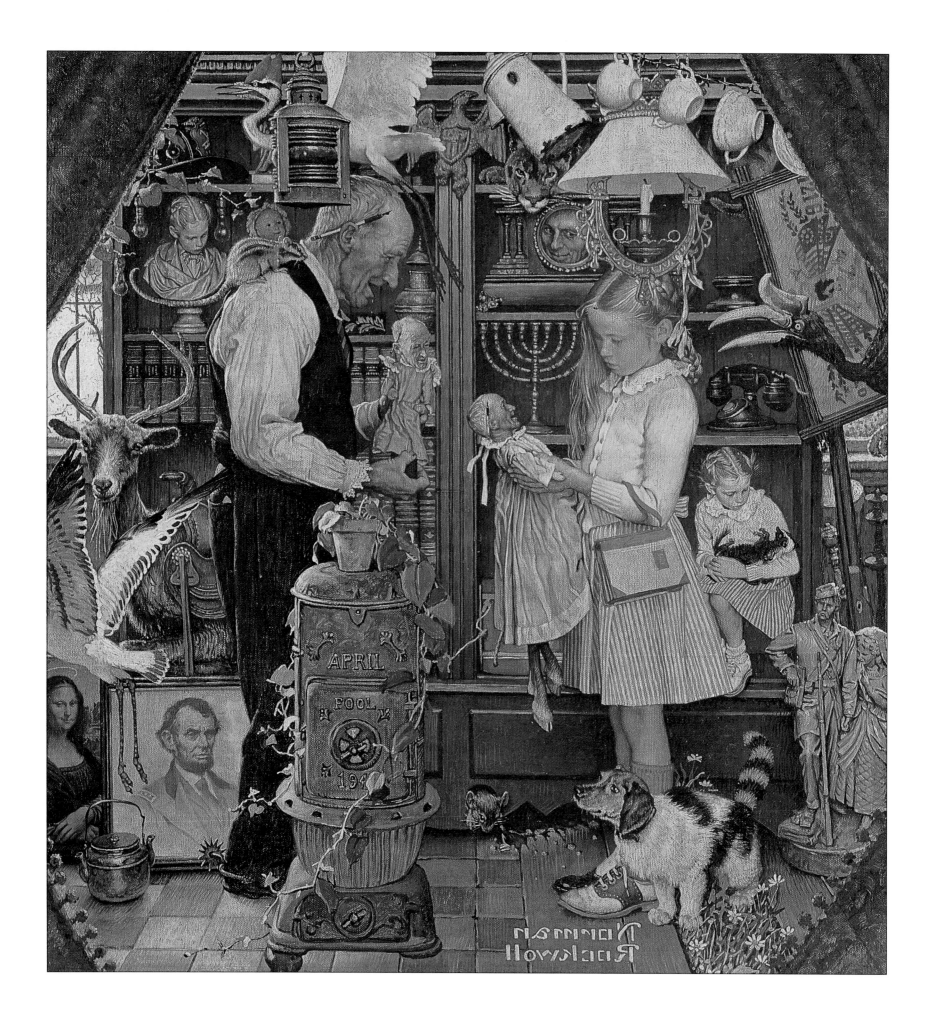

CONTENTS

PREFACE

To many Americans, Norman Rockwell is the best-known artist who ever lived. Each of his cover illustrations for *The Saturday Evening Post* has been seen by millions of people. In addition, he worked for every major magazine over a period of seventy years and was commissioned to paint the portrait of every major presidential candidate from 1952 to 1972. Rockwell's subject matter ranged from product advertisements to sensitive social issues. His work has been reproduced to a phenomenal degree, and his name itself has become a synonym for the small-town values he so often depicted. Almost fifteen years after his death, his reputation continues to grow.

Perhaps the most obvious reason for the popularity of Rockwell's work is its subject matter: he painted America and Americans. His themes are rooted in American values and pride in those values. He did not seek out the ugly or the sordid but chose to accentuate the positive in the American character.

The American family was at the core of Norman Rockwell's work. Because he painted universal situations and relationships, those aspects of family life that transcend a given period of history, his view of family life remains compelling to us today. Rockwell's empathy with his subjects and his attention to detail resulted in pictures of ourselves that are at once authentic and nostalgic.

At the same time, Norman Rockwell was in a unique position to cover the significant events in twentieth-century America and the people who helped shape the nation and the world. During World War II, he created images that became patriotic symbols for a nation at war: Willie Gillis and Rosie the Riveter. He portrayed the Civil Rights Movement and other moral dilemmas in ways all Americans could understand. His portraits of public personalities range from Charles Lindbergh to Neil Armstrong, Harry Truman to Ronald Reagan, and early Gary Cooper to late John Wayne. For seven decades Rockwell's work depicted the events, personalities, and values of a nation.

In 1994, we will celebrate the centennial of Norman Rockwell's birth. His professional career began early in this century, and his work truly covers this century in presenting American life, society, and history. The year 1994 also marks the twenty-fifth anniversary of the opening to the public of The Norman Rockwell Museum at Stockbridge. Norman Rockwell and his wife, Molly, were instrumental in the opening of the museum, which originally featured historical exhibits as well as Rockwell paintings. The museum, which exhibits the largest collection of Norman Rockwell originals in the world, is a center for the study and exploration of Norman Rockwell's illustrations and of the ideas and events depicted in his paintings. Through the museum's exhibitions and programs, visitors can better understand twentieth-century America.

This book, which serves as a Rockwell retrospective, features work from almost every year of his prolific career, spanning the years 1912 to 1976. To examine the images herein is to explore American life in the twentieth century, to see ourselves both as we truly are and, as Rockwell himself said, as we would like to be.

Maureen Hart Hennessey
Curator, The Norman Rockwell Museum
Stockbridge, Massachusetts
January 1993

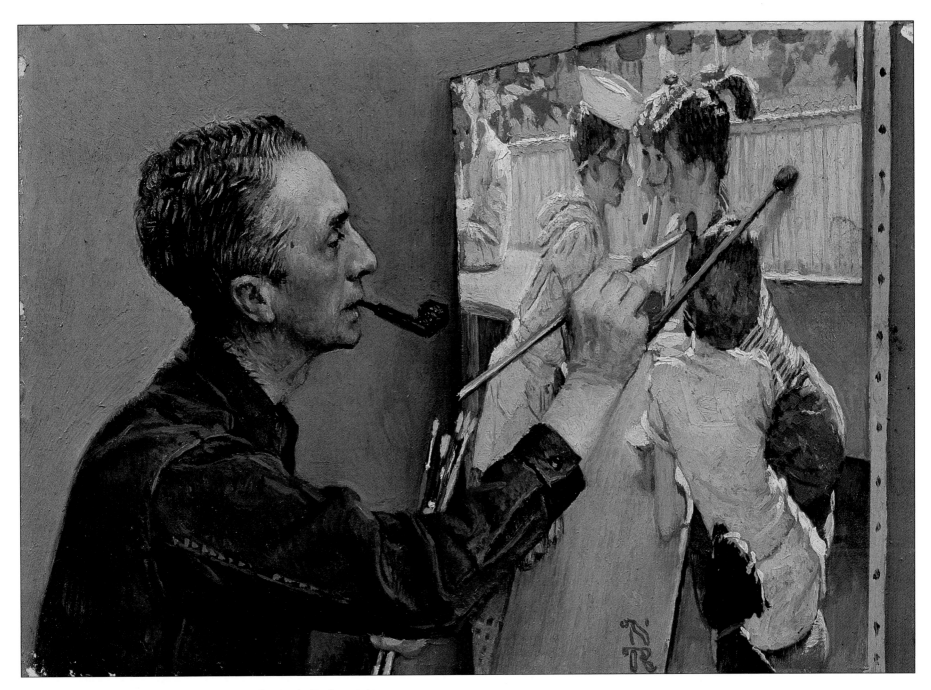

Portrait of Norman Rockwell painting The Soda Jerk, *1953.*

NORMAN ROCKWELL: A GREAT AMERICAN SUCCESS STORY

Norman Perceval Rockwell was born in New York City on February 3, 1894, the second child of Jarvis and Nancy Rockwell. Norman and his brother, Jarvis, enjoyed the urban pastimes of playing stickball and chasing fire engines, but also delighted in the summers that the family spent on a farm in upstate New York. In his writing and illustrations as an adult, Rockwell idealized the country life and contrasted it with the sordid atmosphere of the city, once remarking: "I guess I have a bad case of the American nostalgia for the clean, simple country life as opposed to the complicated world of the city." The Rockwells remained in New York City until 1903, when the family moved to Mamaroneck, New York.

As a boy, Norman Rockwell was non-athletic, clumsy, skinny, and pigeon-toed. He could draw, however, and his ambition, even as a youngster, was to be an illustrator. In 1909, Rockwell left high school to study art full-time, briefly attending the National Academy of Design before enrolling at the Art Students League in New York City. At the age of eighteen, Rockwell began doing illustrations for *Boys' Life*, a new magazine published by the Boy Scouts of America, and within a few months he was named art director. Although Rockwell served as art director for only a few years, his association with the Boy Scouts was lifelong.

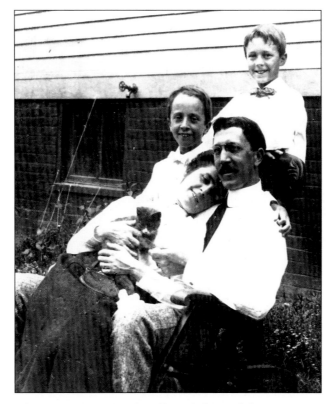

Above: Norman Rockwell (at left) with his parents, Nancy and Jarvis Waring Rockwell, and his brother, Jarvis, c. 1904. Opposite page: Norman Rockwell in his studio in West Arlington, Vermont, c. 1950.

By 1915, Rockwell had moved to New Rochelle, New York, where he established his own studio with the celebrated cartoonist Clyde Forsythe. Rockwell's illustrations soon began appearing in such well-known magazines as *Country Gentleman*, *Literary Digest*, and the children's magazine *St. Nicholas*. His first *Saturday Evening Post* cover, *Boy with Baby Carriage*, appeared on May 20, 1916. This was the first of 321 covers he would create for the *Post*, the most popular magazine of its day, and marked the beginning of an association that would last for 47 years.

Rockwell married Irene O'Connor in 1916, a marriage that ended in divorce in 1929. Two years after his marriage, he enlisted in the navy, serving at the Charleston, South Carolina, Naval Reserve Base during World War I. Rockwell had no official military duties; he served as art editor for *Afloat and Ashore*, the base publication, and painted portraits of naval officers. Since he also was permitted to do his own work, Rockwell illustrations continued to appear in the *Post* and other magazines during the war.

The 1920s found Rockwell back in New Rochelle. He continued to work for the leading publications of his day, but advertising illustrations for new products, ranging from automobiles to Jell-O, now made up a substantial part of his work. In 1925, the first in a series of Boy Scout calendars with Rockwell illustrations appeared; the series would run for

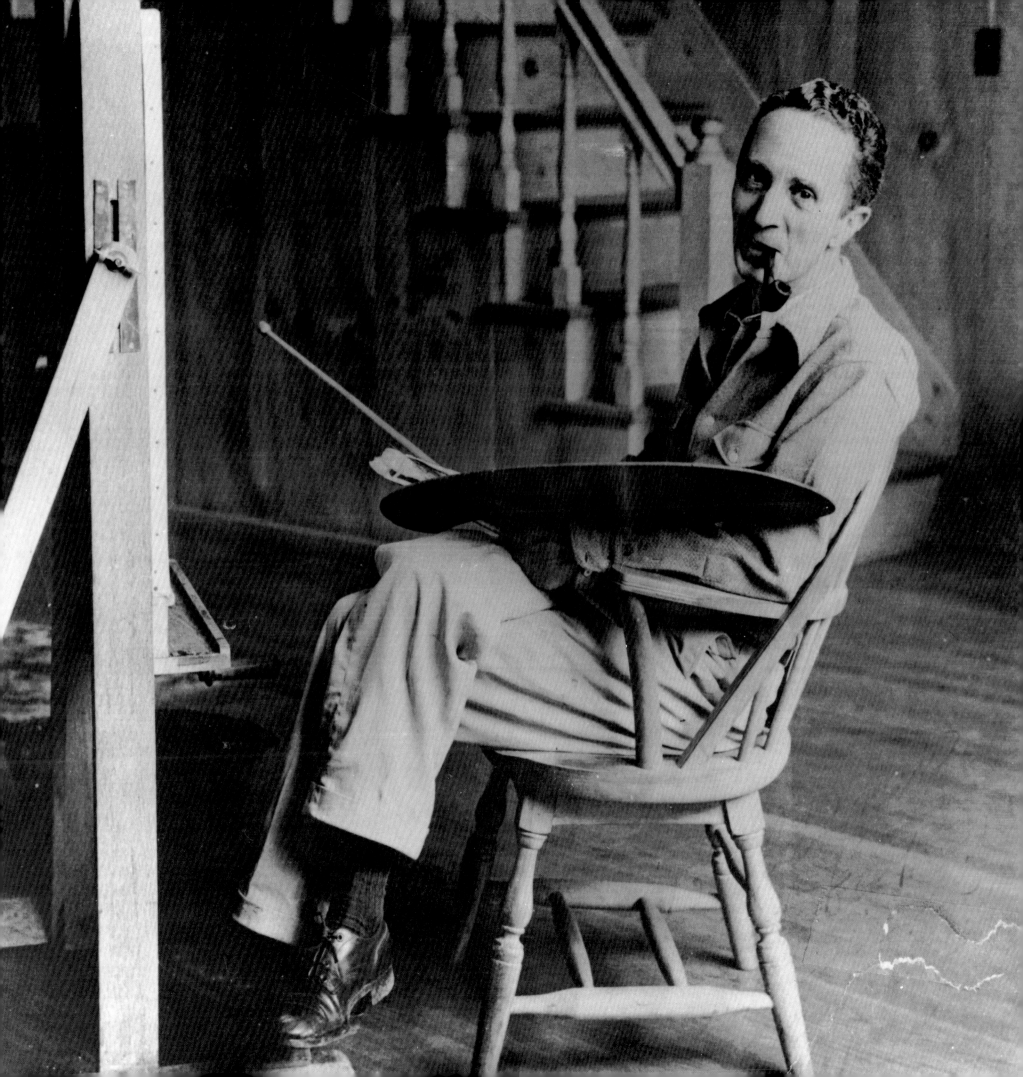

more than fifty years. In 1930, Rockwell met and married Mary Barstow, a young schoolteacher from California. The couple had three sons: Jarvis, Thomas, and Peter. By 1939, the family had moved to Arlington, Vermont, where they lived until 1953.

During World War II, Rockwell's illustrations depicted life on the home front, as well as the adventures of his "everyman" G.I. character, Willie Gillis. *The Four Freedoms*, Rockwell's most famous paintings of the period and some of his most significant works, were completed in 1943 and served as his contribution to the war effort. The paintings illustrate the basic freedoms—freedom of speech, freedom to worship, freedom from want, and freedom from fear—for which Americans were fighting.

During the postwar years, Rockwell continued to chronicle American life on the cover of *The Saturday Evening Post*. In addition, he produced a large number of advertising and commercial illustrations, such as a series of Christmas cards for Hallmark and a series of *Four Seasons* calendars for Brown and Bigelow. In 1953, Rockwell and his family moved to Stockbridge, Massachusetts, where Mary Barstow Rockwell died six years later. *My Adventures as an Illustrator*, an autobiography that Rockwell wrote in collaboration with his son Tom, was published in 1960. Rockwell met a woman named Molly Punderson in 1961, and they were married in October of that year.

Norman Rockwell's last *Post* cover was published in 1963. At that time, a new association with *Look* magazine led to illustrations depicting the major events and social trends of the day. Rockwell's first *Look* illustration, *The Problem We All Live With*, published in 1964, focuses on the Civil Rights Movement; other topics included the space race and the Peace Corps.

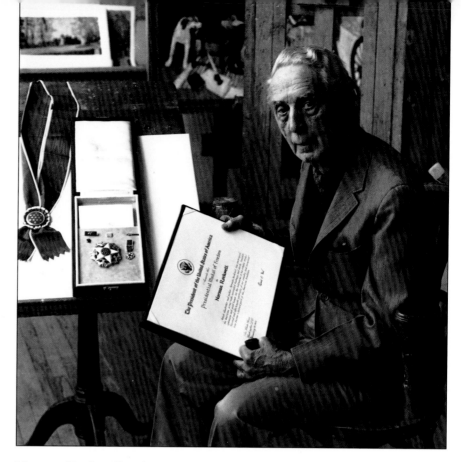

Norman Rockwell in his Stockbridge studio holding the Presidential Medal of Freedom, 1977.

Rockwell continued to paint through the mid-1970s, although he cut back on the number of commissions he accepted. At the age of eighty-two, as the United States celebrated its bicentennial, Rockwell completed his last cover illustration and saw the publication of his final Boy Scout calendar. In early 1977, he was awarded perhaps his highest honor, the Presidential Medal of Freedom, by President Gerald R. Ford, for his "vivid and affectionate portraits of our country." He died at his home in Stockbridge on November 8, 1978.

The Four Freedoms, 1943 (also shown on pages 61 to 64).

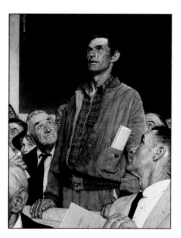

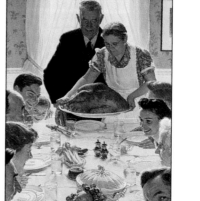

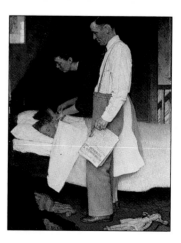

How Norman Rockwell Made His Pictures

Norman Rockwell was a perfectionist and a consummate craftsman. During his sixty-year career as an illustrator, he dedicated himself to traditional oil painting. This meant following several basic steps in creating an illustration. Sketches, drawings, and color studies led to a final oil painting, which would later be reproduced as a magazine cover, story illustration, or advertisement. For each commission, Rockwell repeated the same multistep process with only occasional variations.

The first step was to develop a good idea, either his own or that of a client, friend, or colleague. Early in his career, Rockwell found it difficult to come up with new ideas. "Thinking up ideas was the hardest work I did in those days," he wrote. Later, he noted: "Years ago, I used to sit around for days dreaming up ideas, but I won't live long enough to do all the ideas I have now."

Norman Rockwell developed ideas by sketching. He was in constant communication with art editors, advertising agencies, and clients to be sure that the idea for the illustration met with their approval. He would also test his ideas on friends and family to get their reactions. Once the idea sketch was approved, Rockwell would search for the best models, costumes, and props. "Rockwell will spare neither time nor expense in finding the right model or object needed to fit into the subject he is painting; he never fakes," said cartoonist Clyde Forsythe.

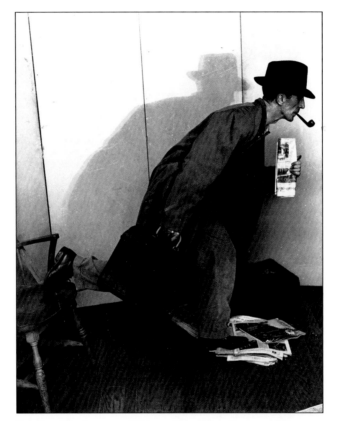

Rockwell often used himself in his pictures. Here, he poses as a commuter for Crestwood Station, *1946.*

Early in his career, Rockwell worked with live models, who were required to hold poses for long periods of time. In the 1930s, he began using photographs, which helped in recording transient effects, difficult poses, and subject matter far from the studio. Rockwell did not generally take the photographs himself, preferring to play the part of producer and director.

Once Rockwell established the outline of the picture, he began to work out the problems in painstaking detail. "It is in the charcoal drawing that I start with the first rough sketch and, with the help of the photographs of models and props, completely develop the story and solve, to the best of my ability, all the problems of drawing, composition, and tone—in fact every problem but that of color," Rockwell explained. While perfecting ideas, Rockwell often erased portions of these charcoal drawings and reworked them. Sometimes this reworking would wear a hole in the paper. When this happened, he would cut out the mistake, insert a fresh sheet of paper, and start over.

Once satisfied with the charcoal drawing, Rockwell would do a color study. At this stage of his process, Rockwell was not concentrating on detail but was establishing the color scheme and values for the final oil painting. "I made it [the color study] the exact size of the magazine cover," he said. "By doing this, I was able to judge better how it would show up on

the news stands . . . color can aid greatly in expressing an idea and very often can set the mood of your picture."

The final step of Rockwell's picture-making process was the actual oil painting. As he painted, he surrounded himself with his preliminary works as reference materials. Rockwell's painting surface was usually a linen canvas tacked onto a stretcher, which underwent a number of preparatory layers before the actual painting with oils began. The underdrawing of the image was the first layer. Rockwell then primed the canvas with a thin wash of oil paint and turpentine, which allowed the drawing to show through, basing the color of this *imprimatura* step on the dominant color of the painting. The following layer was the underpainting of the figures. Following a practice of the old masters, Rockwell most frequently applied the underpainting in Mars Violet diluted with turpentine. He loved this color and felt it gave a warmth and richness to the painting. When the underpainting was dry, Rockwell sealed the canvas with French varnish,

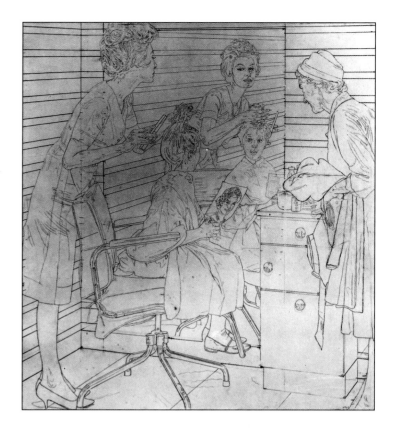

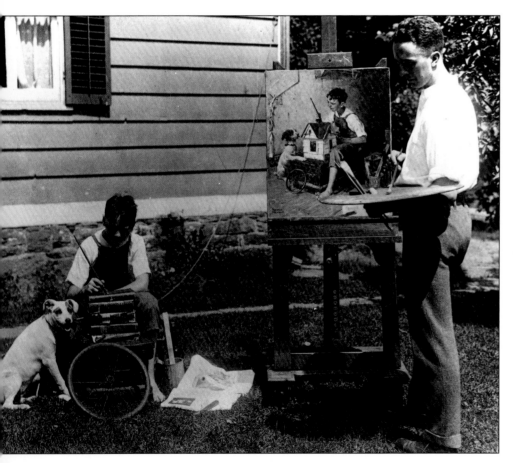

In the first decades of his career, Norman Rockwell painted directly from live models. In this photograph from 1921 he works on Painting the Little House.

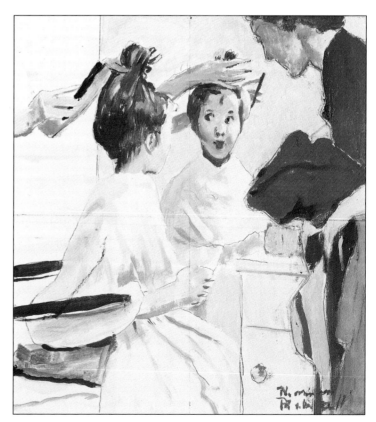

Two Rockwell studies for First Trip to the Beauty Shop, *1972.*

and then began painting with oils. This process enabled Rockwell to remove mistakes easily, without removing the underpainting.

When the oil painting was finished, Rockwell sent it to the client framed. "It will give the editors the proper impression of my painting. They won't be distracted by the tacks and the rough edges of the canvas, or by other disturbing elements near by," he said. "My motto is, 'the poorer the picture, the better the frame.' Another thing, the frame is protection in transportation." To meet his deadlines, paintings often went out barely dry. The next time Rockwell saw the illustration, it was in its reproduced form in a magazine. Once reproduced, the paintings usually were returned to Rockwell, after which he occasionally gave them away.

Rockwell's attention to detail and his penchant for accuracy come through in his work. For **The Connoisseur** *in 1962, Rockwell used the drip painting style of Jackson Pollack to create his own abstract work.*

Norman Rockwell followed these steps throughout his career. He approached each commission with enthusiasm, excitement, and perfectionism. He worked and reworked sections of his pictures until he felt that they were just right. Norman Rockwell's creative process reveals his dedication to his craft, his sense of humor, and his extraordinary ability to successfully tell enduring stories. When asked what work of his own was his favorite, Rockwell would quote Picasso and say, "the next one."

How Norman Rockwell Made His Pictures

ROCKWELL RETROSPECTIVE

NOTE: This retrospective features at least one work from almost every year of Norman Rockwell's prolific career, which spanned the years 1912 to 1976. In the mid-1970s, while in his eighties, Rockwell accepted fewer commissions and, therefore, not every year of that decade is represented here.

Dating Rockwell's work is a task at once easy and difficult. As so much of Rockwell's work was published, dating to within a year or two of execution is usually possible. Determining the exact year is more difficult. Calendar illustrations, for example, had to be worked on a year or two in advance of publication. Since Rockwell did not usually date his works, the dates that are provided here with the paintings refer to the year of publication. Dates that are approximate are indicated by the term "c." (circa). When available, the dimensions and medium of the original artwork are given as well.

Dyckman House

Oil on canvas
6 × 12 inches
(15 × 30cm)
1912

The earliest surviving Rockwell painting, this work, done by Rockwell at the age of eighteen, is set in a historic house in Rockwell's native New York City.

TELL-ME-WHY STORIES

Rockwell's first professional commission, arranged by one of his teachers while he was still a student, was the illustration of a book called *Tell-Me-Why Stories About Mother Nature*. The *Tell-Me-Why* illustrations show fantastic landscapes quite unlike subsequent works by Rockwell. It would seem that the young illustrator was experimenting and developing a style, which would later come to focus increasingly on people and less on landscape.

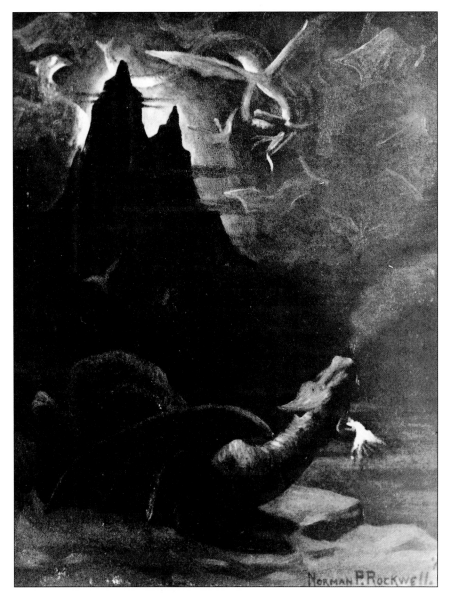

Mastodons, Pterodactyli and Icthyossauri
1912

The Bear
1912

Heinz Baked Beans—Scouts Camping
1912

As a young man, Rockwell made an oath in art school with two of his classmates: "[We] signed our names in blood, swearing never to prostitute our art, never to do advertising jobs, never to make more than fifty dollars a week." That oath was broken early, as this 1912 advertisement for Heinz Baked Beans certifies.

BOY SCOUT HIKE AND CAMP BOOKS

In 1913, Rockwell was commissioned to illustrate the first handbooks on outdoor skills published by a young organization called The Boy Scouts of America. Rockwell's illustrations for *The Boy Scout Hike Book* (1913) and *The Boy Scout Camp Book* (1914) contrast sharply with the line-drawing style that Rockwell perfected in later years. Yet the early Boy Scout sketches were pioneer drawings for this type of book illustration and show Rockwell's eye for detail and his attention to the smallest of tasks.

Blanket as Overcoat (Hike Book)

Right Posture Walking (Hike Book)

Getting a Move On (Hike Book)

Dutch Oven (Hike Book)

Pack on Horse (Hike Book)

Lean-to (Hike Book)

Sportmen's Tents (Camp Book)

Troop Cooking Kit (Camp Book)

Sun Dance Plan for Camp (Camp Book)

Norman Rockwell

Putting the Last Ounce in It (Camp Book)

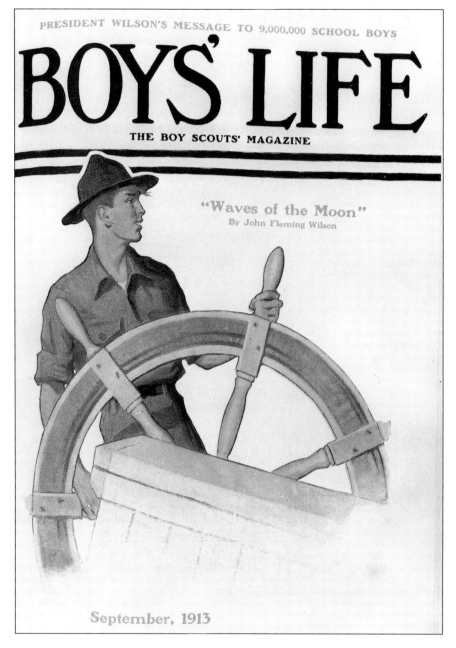

PRESIDENT WILSON'S MESSAGE TO 9,000,000 SCHOOL BOYS

BOYS' LIFE
THE BOY SCOUTS' MAGAZINE

"Waves of the Moon"
By John Fleming Wilson

September, 1913

Not All of Scouting Is To Scout (Camp Book)

Scout at Ship's Wheel
1913

Concurrent with his book and calendar work for the Boy Scouts, Rockwell contributed to *Boys' Life*, the Boy Scouts' magazine. Published in September of 1913, this is his first cover for that publication.

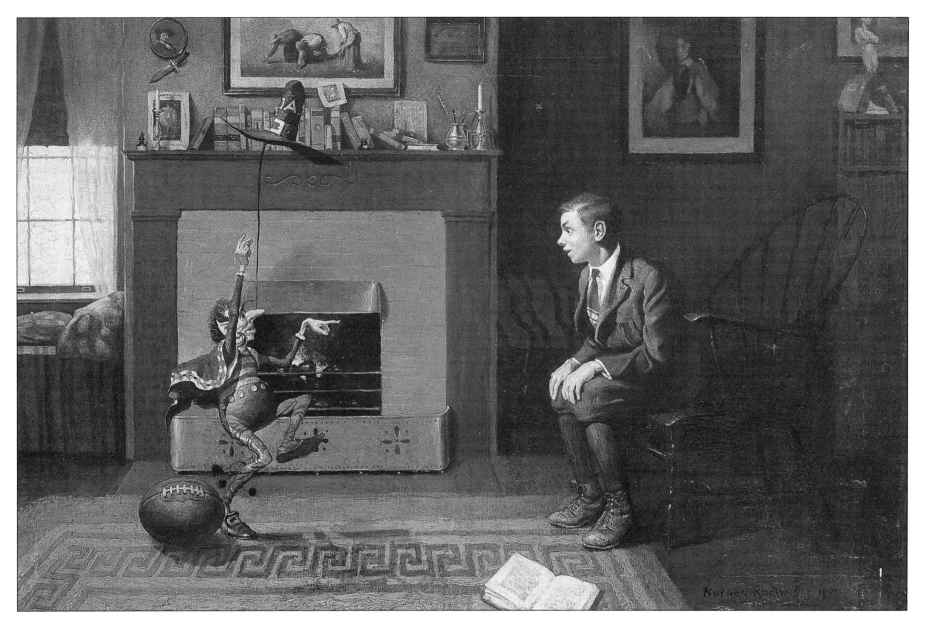

The Magic Foot-ball
Oil on canvas
19.75 × 29.5 inches (50 ×75cm)
1914

Although the look of this story illustration from 1914 is different from much of
Rockwell's later work, he incorporated elements that he would later use again and
again throughout his career, such as light filtering through a window, and reference
to other artists' work—in this case Millet's *The Gleaners* and two Rembrandtesque
portraits.

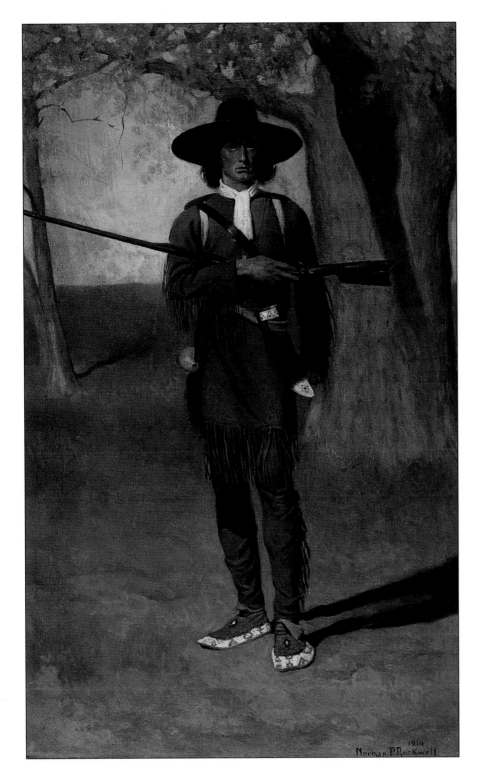

Daniel Boone, Pioneer Scout
Oil en grisaille on canvas
20 × 12.5 inches (51 × 32cm)
1914

In 1913, Rockwell was named art director for *Boys' Life,* and in that capacity was paid $50 a month to both select and create illustrations for the publication. He even had to approve his own work, such as this 1914 story illustration.

A Double Gift
Charcoal and green wash on board
13 × 25.5 inches (33 × 65cm)
1915

Rockwell had many different ways of signing his name. Sometimes only his initials appear on a painting. The "P" stands for Perceval, a family name of which Rockwell was not fond.

Boy With Baby Carriage

Oil on canvas
20.75 × 18.625 inches
(53 × 47cm)
1916

This was the first of 321 *Saturday Evening Post* covers that Rockwell did over a 47-year period. In 1916, when this cover appeared, Rockwell was 22 years of age. One model posed for all three boys, showing Rockwell's ability to create distinctive characters from the same subject.

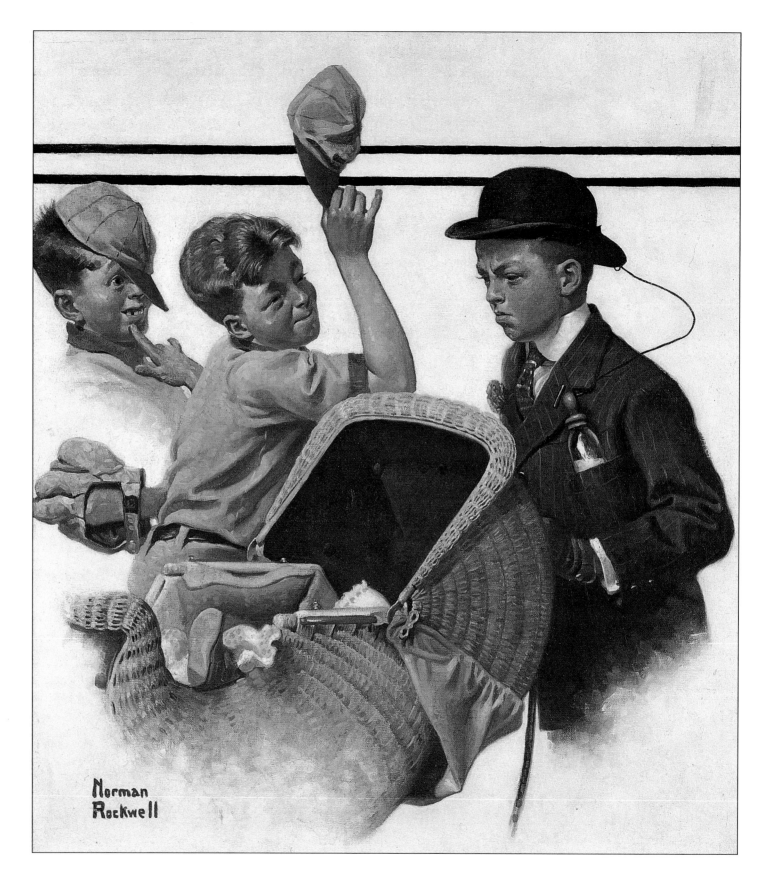

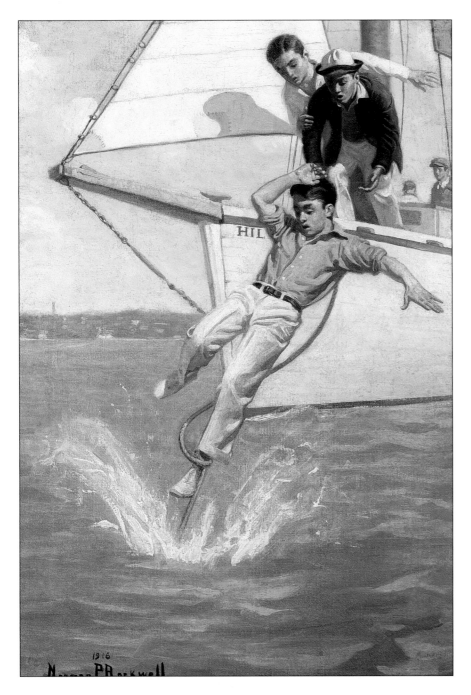

Slim Finnegan
Oil
27 × 22 inches (69 × 56cm)
1916

Boys and dogs are popular themes in much of Rockwell's early work. His choice of a bulldog to reflect the stance of Slim Finnegan is perfect for creating just the right mood. Imagine how different the story in the picture would be had Rockwell instead chosen a collie or a dachshund.

Pride-o-Body
Oil en grisaille on canvas
23.5 × 17 inches (60 × 43cm)
1916

The term *en grisaille*—the technique in which this picture was done—means painting monochromatically, usually in gray.

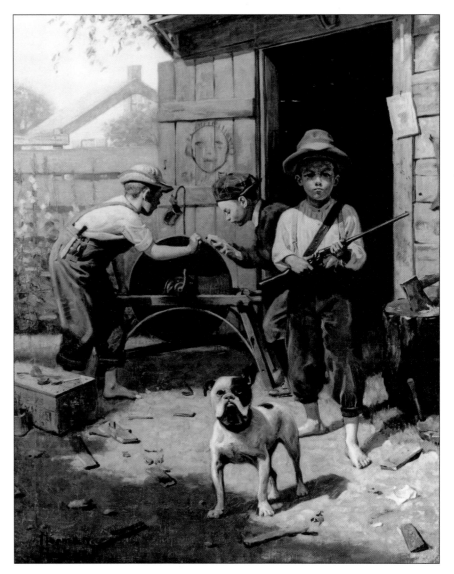

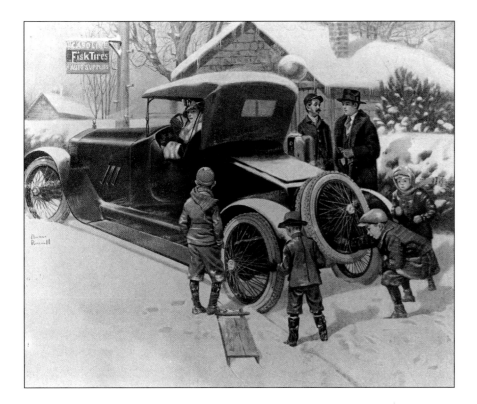

Winter Scene and Auto
Oil on canvas
24 × 27 inches (61 × 69cm)
1917

Rockwell produced two series of advertisements for Fisk Rubber Tire Company, one for bicycle tires and one for automobiles. Both series featured the popular Rockwell motif of young boys.

Cousin Reginald Spells Peloponnesus
Oil on board
30 × 30 inches (76 × 76cm)
1918

Finding the right model was only one step in Rockwell's creation of a character. "When I'd finally found the right boy I had to persuade him to pose. 'Gee, Mister,' he'd say, 'I gotta play ball on Satiddy. I can't do no posin'.' 'Fifty cents an hour,' I'd say. 'I dun know,' he'd say. 'You gonna pay me fifty cents just ta stand there?' "

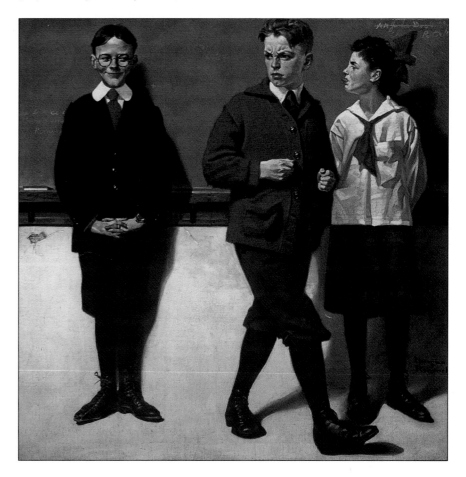

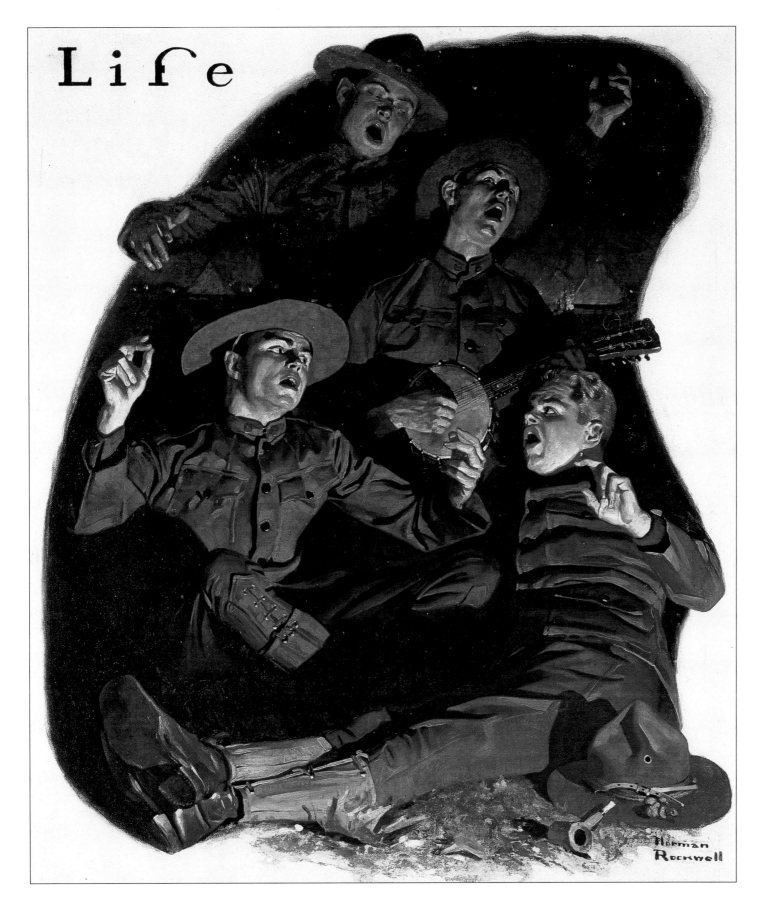

Over There
1918

Used on the cover of *Life* magazine and on sheet music for a popular World War I song, this image evokes cheerful camaraderie and wartime friendships. For Americans, the horrors of World War I were truly "over there."

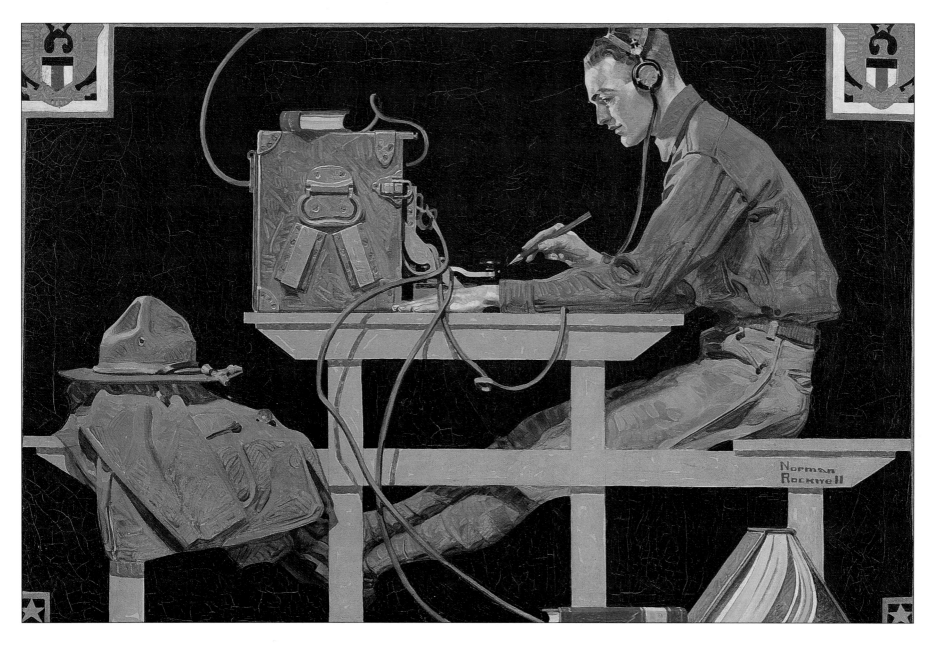

The US Army Teaches Trades
Oil on canvas
19.5 × 29.5 inches (50 × 75cm)
1919

This Army recruiting poster emphasizes the personal benefits gained by military service, the same pitch used today. The stylized soldier is reminiscent of the work of the illustrator J.C. Leyendecker, one of Rockwell's heroes.

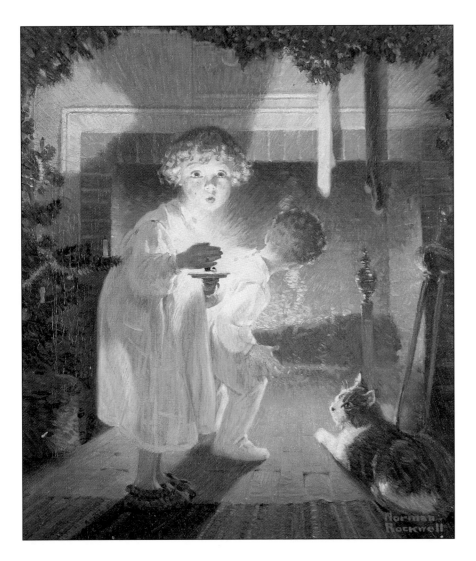

Is He Coming?
Oil on canvas
21 × 18 inches (53 × 46cm)
1920

Holidays and celebrations were popular
Rockwell themes. Rockwell contributed some of
his most cherished illustrations for use as cover
art at holiday times, as this 1920 *Life* magazine
cover attests.

And the Symbol of Welcome Is Light
Oil on canvas
40 × 28 inches (102 × 71cm)
1920

Norman Rockwell's success and popularity as
an illustrator brought him celebrity status at a
young age. As a result, many companies
commissioned him to create illustrations to
advertise their products, such as this ad for the
Edison Mazda Lampworks.

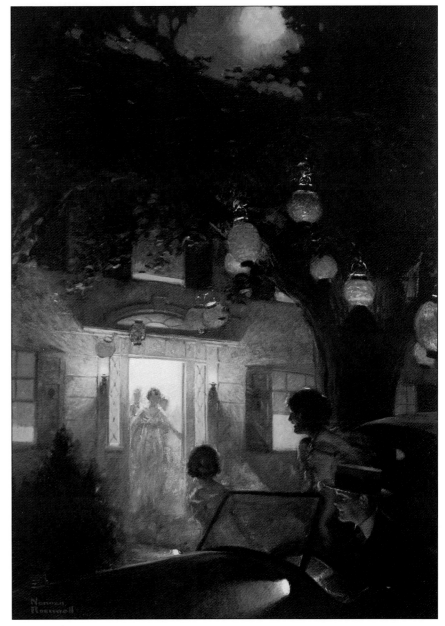

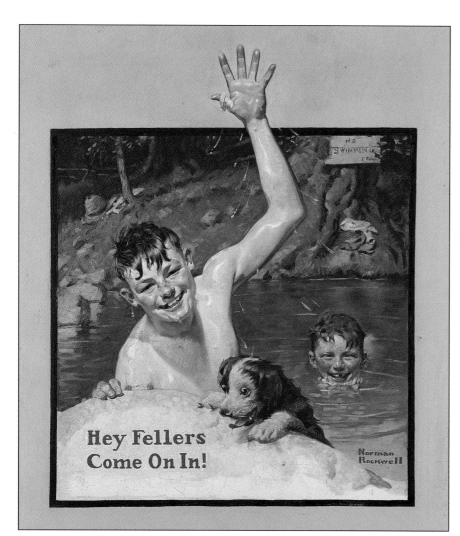

No Swimming
Oil on canvas
25.25 × 22.25 inches (64 × 57cm)
1921

Although the black outline frames the boys
and dog in *No Swimming*, it emphasizes the
painting's impression of haste and greatly adds
to the overall sense of motion.

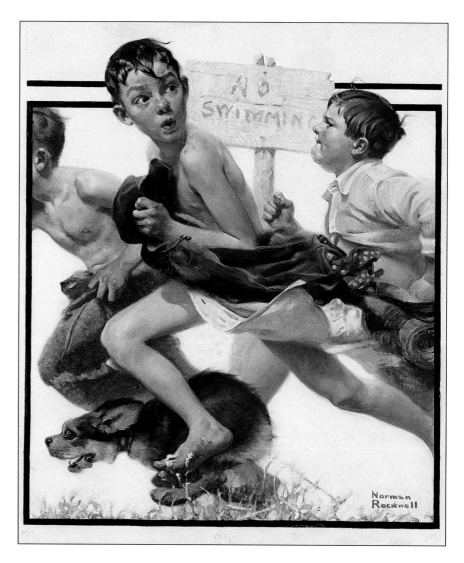

Hey Fellers Come On In!
Oil on canvas
20 × 19.75 inches (51 × 50cm)
1920

Notice the connection between this 1920
Country Gentleman cover and the 1921
Saturday Evening Post cover called *No
Swimming*. Rockwell often reused ideas that
worked.

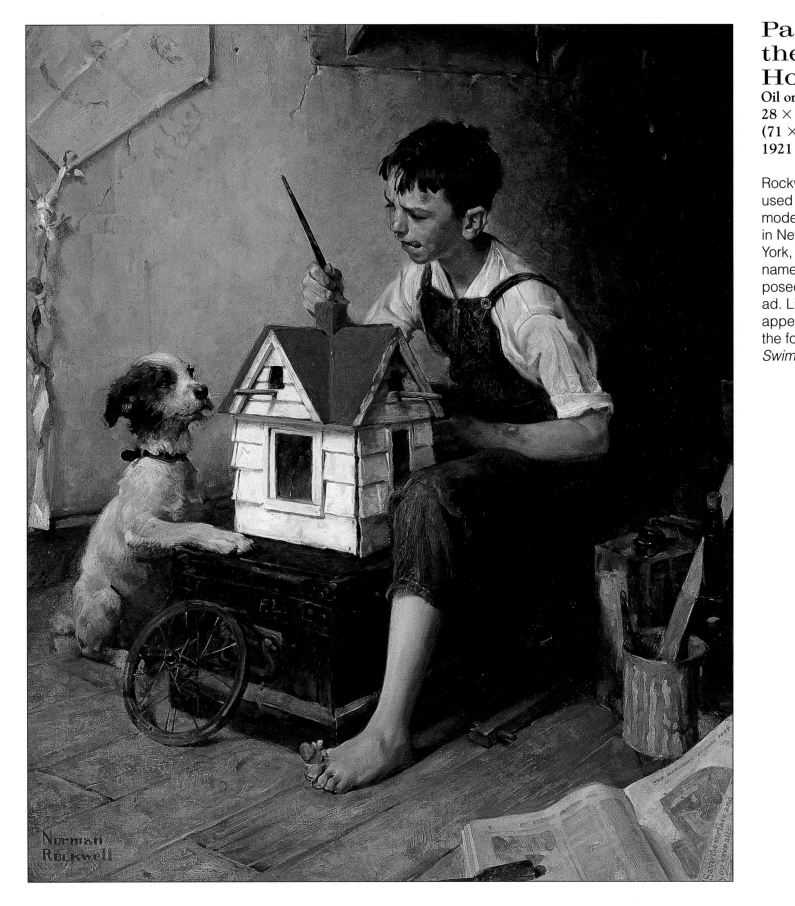

Norman Rockwell

Painting the Little House
Oil on canvas
28 × 24 inches
(71 × 61cm)
1921

Rockwell frequently used his neighbors as models. While he lived in New Rochelle, New York, a young neighbor named Franklin Lischke posed for this charming ad. Lischke also appears as the boy in the foreground in *No Swimming*.

I'm Thinking About My Kiddie
Oil en grisaille on canvas
12 × 18 inches (30 × 46cm)
1922

This 1922 advertisement for Raybestos brakes makes its pitch to women drivers, unusual for the time.

The Stuff of Which Memories Are Made
Oil on canvas
38.5 × 26.5 inches (98 × 67cm)
1922

Rockwell's use of light is often striking—very appropriate for the Edison Mazda Lampworks advertisements.

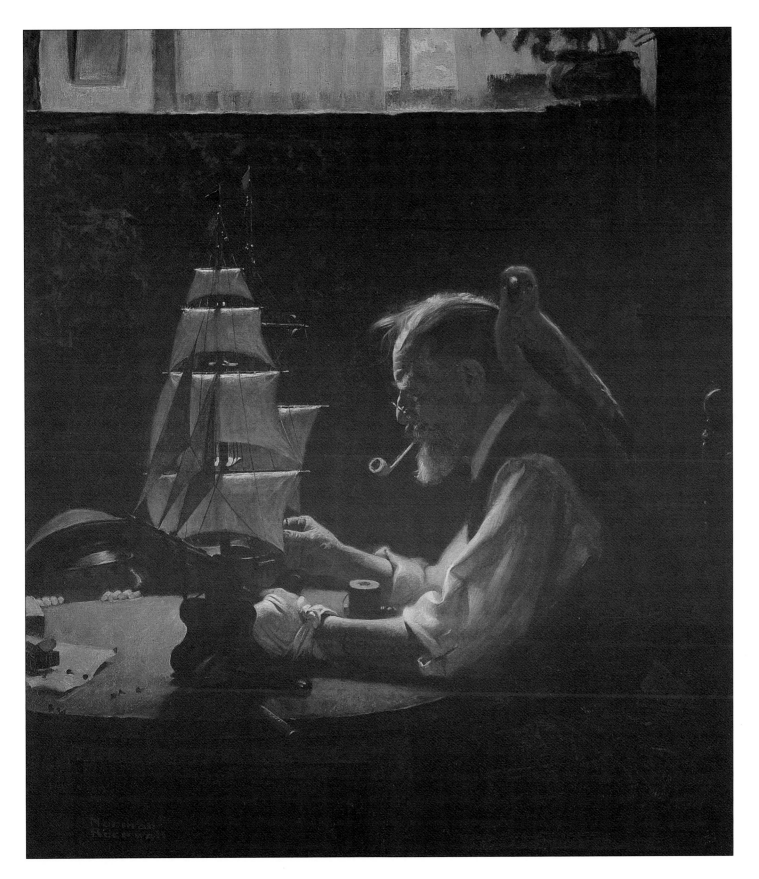

For a Good Boy
Oil on canvas
29.5 × 24 inches
(75 × 61cm)
1922

Rockwell's covers for *Literary Digest* were often family-oriented, exploring the relationships among children, parents, and grandparents.

Home
Sweet
Home
1923

Unlike much of his other cover work, Rockwell's covers for *Life,* like this melancholy shipboard scene, often did not involve children.

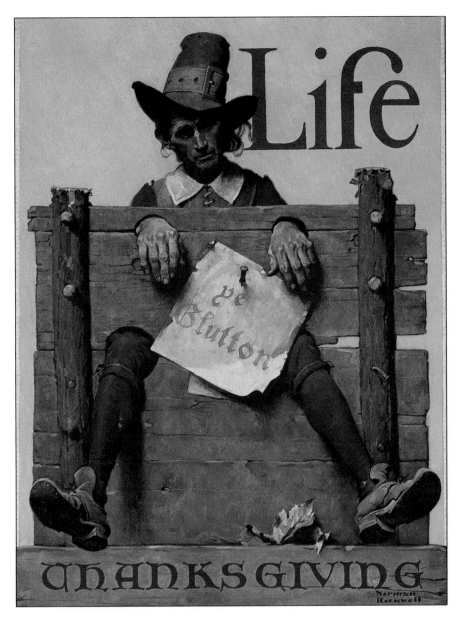

Thanksgiving—Ye Glutton

Oil on canvas
31 × 22 inches (79 × 56cm)
1923

Life was a humor magazine during the time that Rockwell was contributing to it. Often, the covers of the magazine, such as this one from 1923, were a joke. Does this Pilgrim look anything like a glutton?

Christmas Trio

Oil on board
28.25 × 21.5 inches (72 × 55cm)
1923

As a youngster, Norman Rockwell frequently sat and listened to his father read from Dickens novels, often sketching the characters in the stories from their descriptions. Period pieces with a Dickensian flare were common in Rockwell's early work.

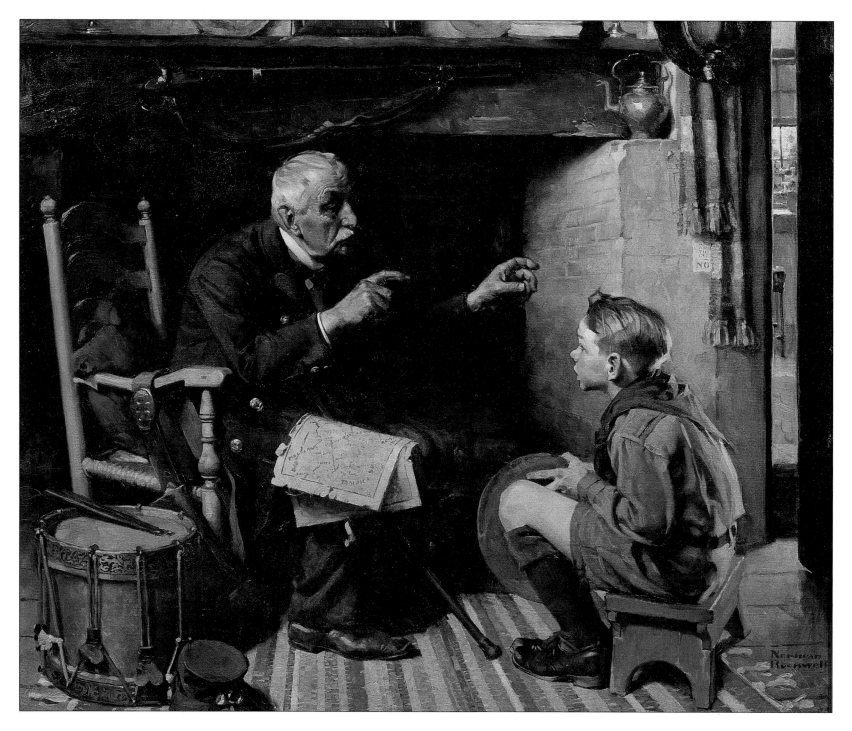

Youth and Old Age
Oil on canvas
26.5 × 32 inches (67 × 81cm)
1924

Early ads were often narrative pictures with little direct correlation between the picture and the product, as this 1924 advertisement for Colgate Dental Cream exemplifies. Its slogan was: "If your wisdom teeth could talk, they'd say 'Use Colgate's.' "

Boy Scout Calendars

Continuing his association with the Boy Scouts, Rockwell began to illustrate the Boy Scout calendar, and every year from 1925 to 1976 a Rockwell illustration graced the cover. His illustrations also appeared on each year's February issue of *Boys' Life*. Next to *The Saturday Evening Post*, the Boy Scout calendar series is perhaps Rockwell's best-known and most popular work.

A Good Scout
Oil on canvas
22 × 30 inches (56 × 76cm)
1925

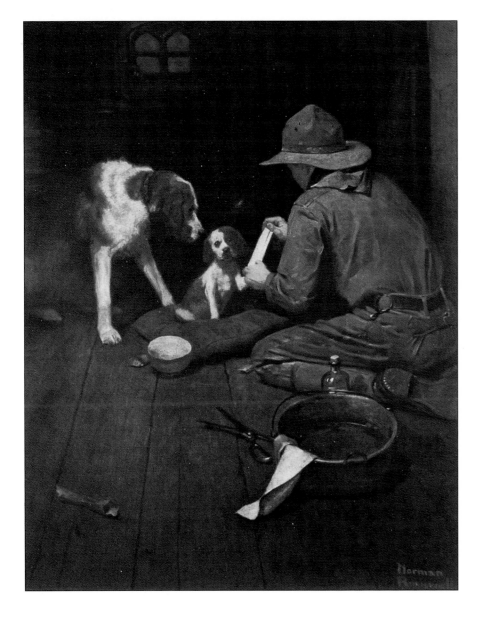

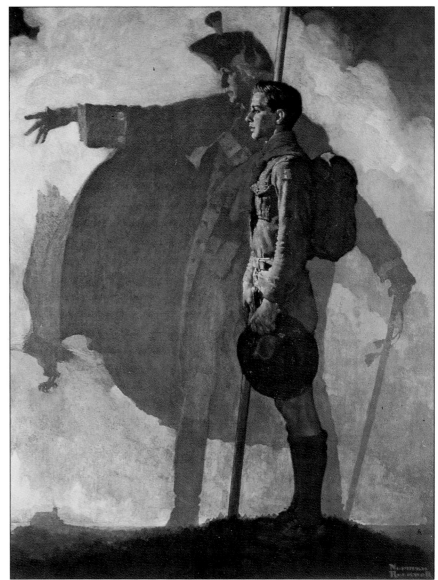

A Scout Is Loyal
Oil on canvas
44 × 34 inches (112 × 86cm)
1932

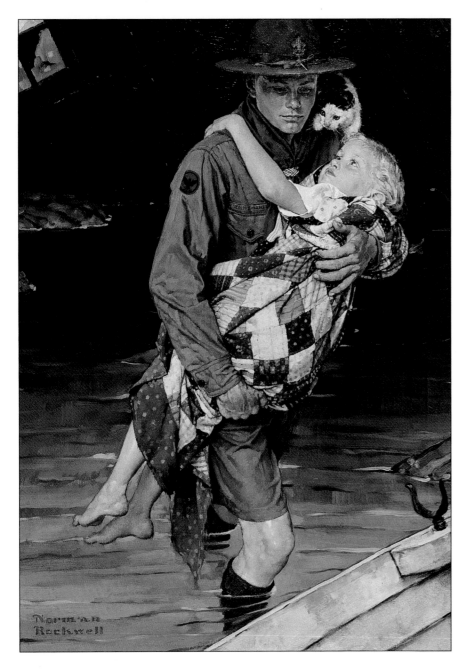

A Scout Is Helpful
Oil on canvas
34 × 24 inches (86 × 61cm)
1941

The Adventure Trail
Oil on canvas
35 × 27 inches (89 × 69cm)
1952

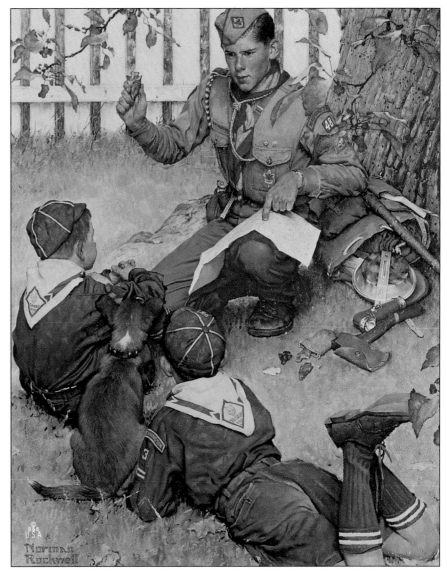

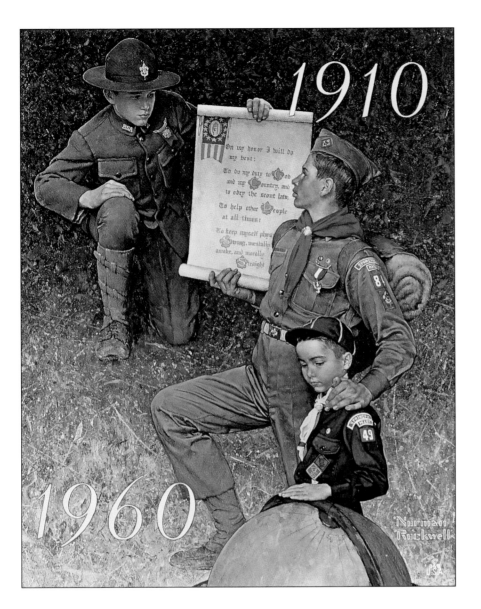

Ever Onward

Oil on canvas
37 × 29 inches (94 × 74cm)
1960

From Concord to Tranquility
1973

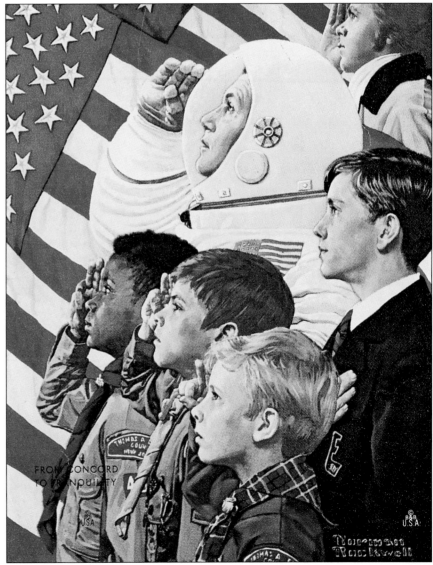

Puppy Love

Oil on canvas
24 × 20 inches
(61 × 51cm)
1926

Norman Rockwell's
use of children as
primary subjects was
encouraged by the
Post editors and
helped make his
paintings extremely
popular throughout
the rest of his career.

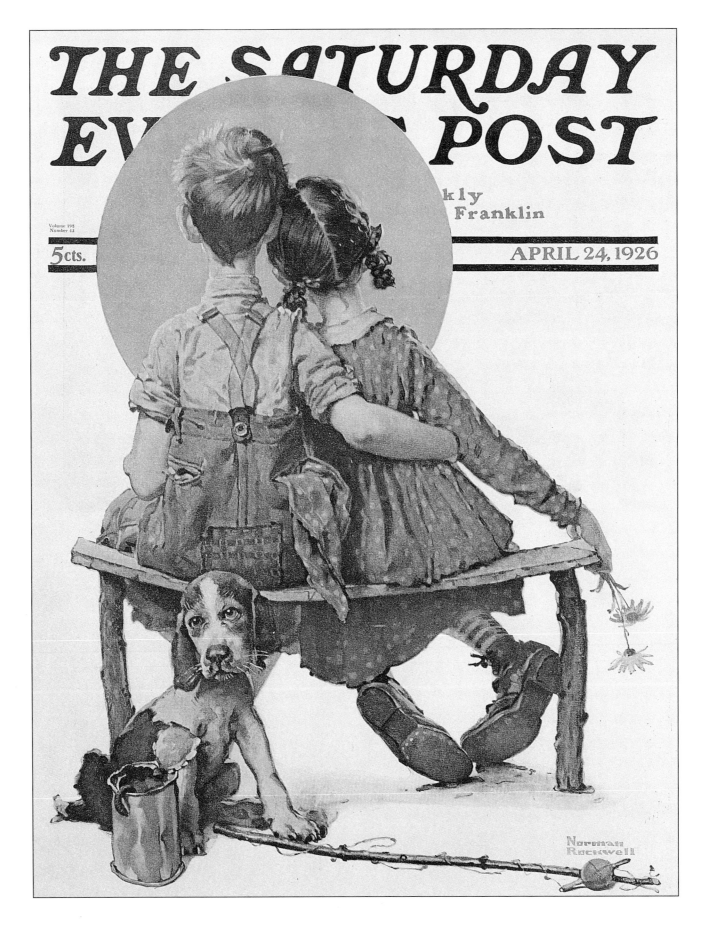

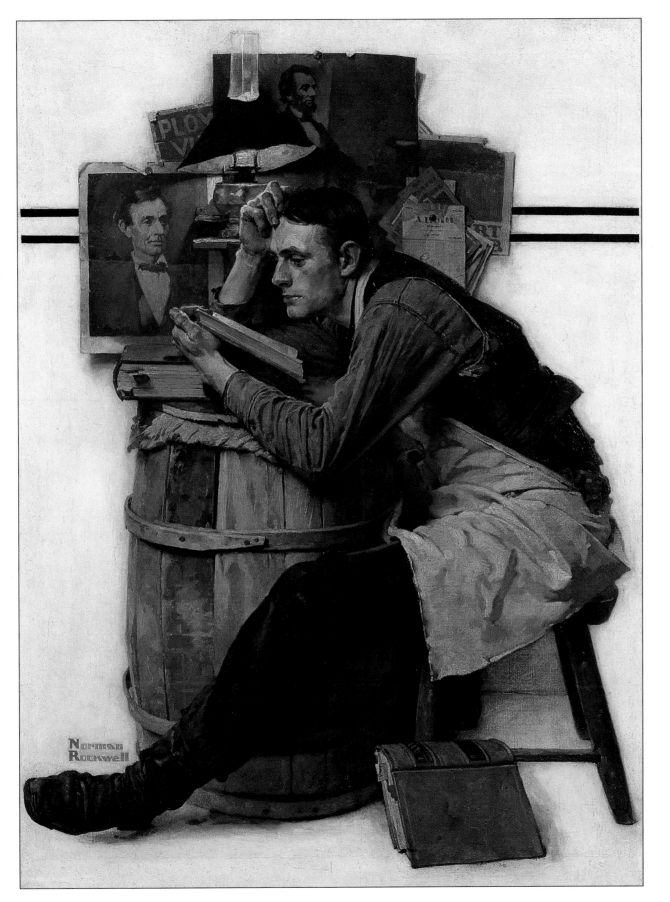

The Law Student
Oil on canvas
36 × 27.5 inches
(91 × 70cm)
1927

This *Post* cover
commemorated
Abraham Lincoln's
birthday in 1927. Like
the young man in the
picture, Rockwell was
an admirer of Lincoln
and used him as a
subject in several
illustrations.

Outward Bound

Oil on canvas
39.375 × 32.5 inches
(100 × 83cm)
1927

Rockwell was a master at capturing the facial expressions, emotions, and moods of the characters in his illustrations. In this 1927 story illustration, Rockwell uses a motif that was uncommon for him: not showing the faces of his subjects. Nevertheless, Rockwell made the nature of the interaction between the two maritime figures quite clear.

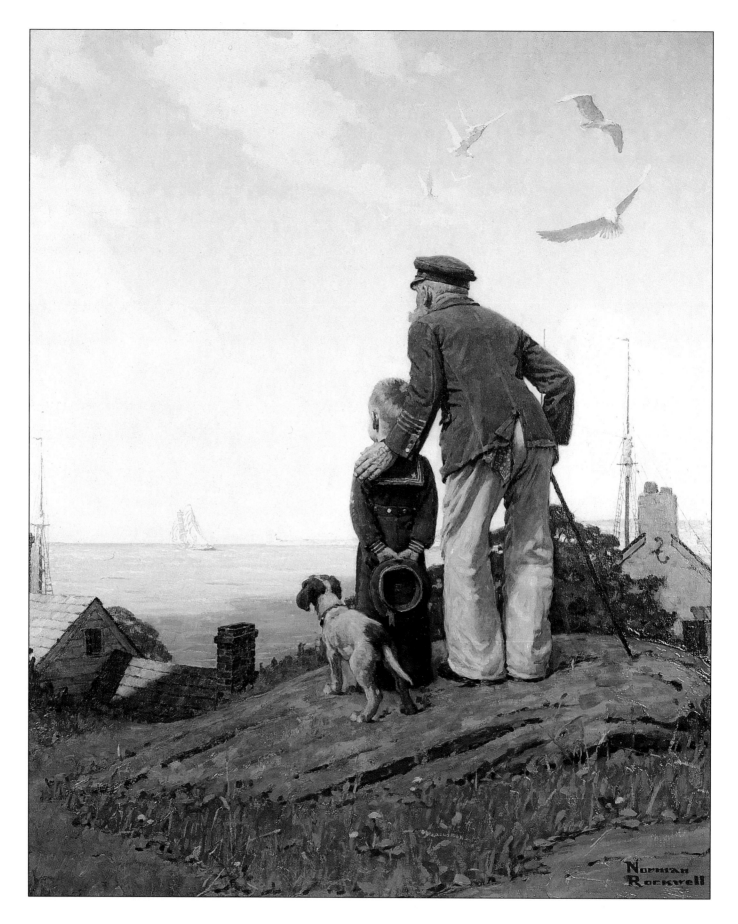

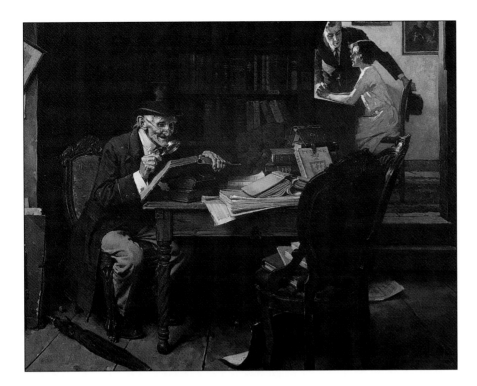

The Book of Romance
Oil on canvas
32 × 42 inches (81 × 107cm)
1927

Many of Rockwell's paintings for *Ladies Home Journal* during this period were highly detailed and in full-color, thanks to the growing sophistication of both the printing process and Rockwell's work.

Gilding the Eagle
Oil on canvas
27 × 21 inches (69 × 53cm)
1928

Only two years prior to the appearance of this *Saturday Evening Post* cover, it would not have been possible for Rockwell to use gold paint for the eagle in the picture, since the old two-color printing method used by the *Post* would not have allowed its reproduction.

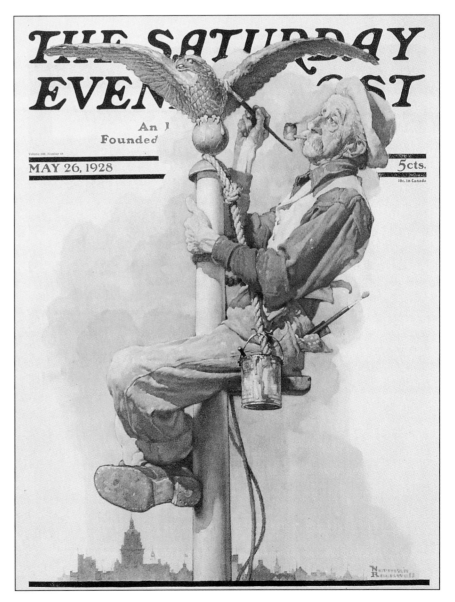

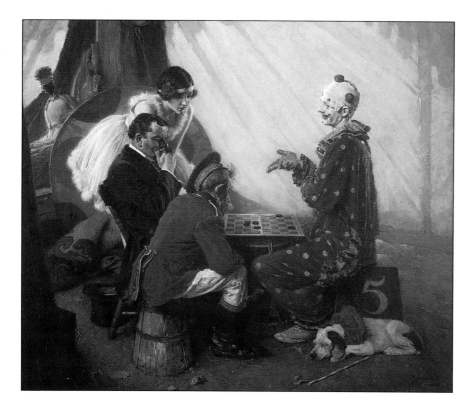

Checkers
Oil on canvas
35 × 39 inches (89 × 99cm)
1928

Once magazine illustrations were printed using
the four-color printing process introduced to the
Post in 1926, illustrators could see their work
reproduced in full-color with all its rich tones and
color variations. It also offered them greater
flexibility in their work.

Welcome to Elmville
Oil on canvas
33 × 27 inches (84 × 69cm)
1929

The speed trap, which came about as
automobiles became more widely owned,
provided inspiration for this *Saturday Evening
Post* cover. Rockwell himself had been caught in
a speed trap several months before this cover
appeared—he was not in Elmville, however,
which is a fictional town.

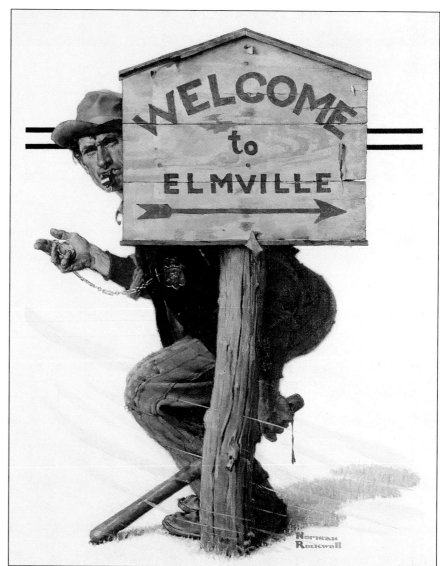

People Reading Stock Exchange

Oil on canvas
38 × 30 inches (97 × 76cm)
1930

This *Saturday Evening Post* cover is the only one in which Norman Rockwell looks at the Great Depression, which began in 1929 and lasted into the mid-1930s. It also contains a rare Rockwell mistake—if you look closely, you'll see that the delivery boy has three legs.

Fruit of the Vine

Oil on canvas
31 × 27 inches (79 × 69cm)
c. 1930

Rockwell created over eight hundred ads for nearly two hundred companies and organizations, from Acme Markets to Western Union, including the one for Sun Maid Raisins seen here.

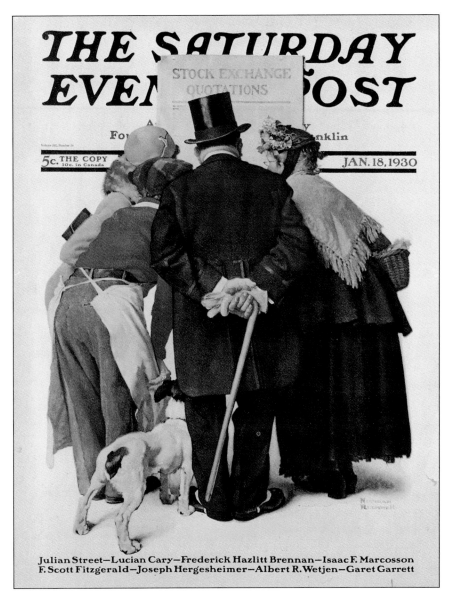

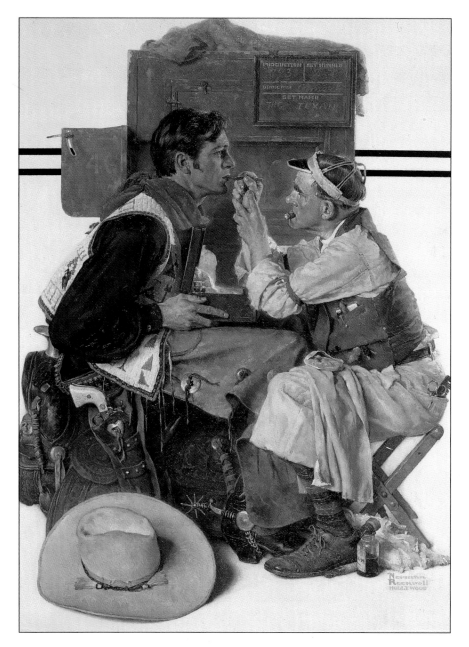

Gary Cooper as the Texan

Oil on canvas
35 × 26 inches (89 × 66cm)
1930

Norman Rockwell often painted celebrities. He painted movie stars, politicians, and many others in the public eye in formal portraits as well as in candid moments.

Men Racing to Fire

Oil on canvas
41 × 31 inches (104 × 79cm)
1931

In this *Post* cover, Rockwell experiments with dynamic symmetry, a compositional technique in which diagonal lines create movement and tension.

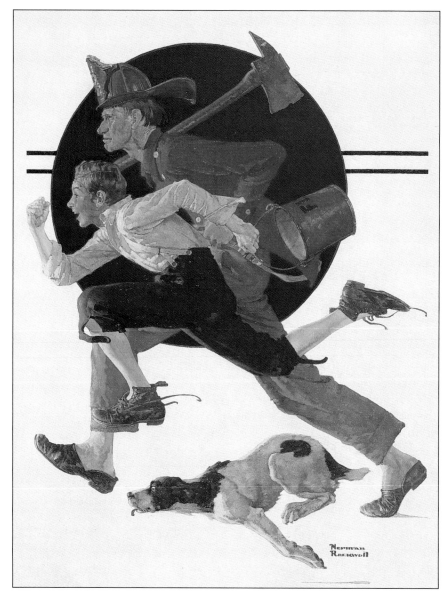

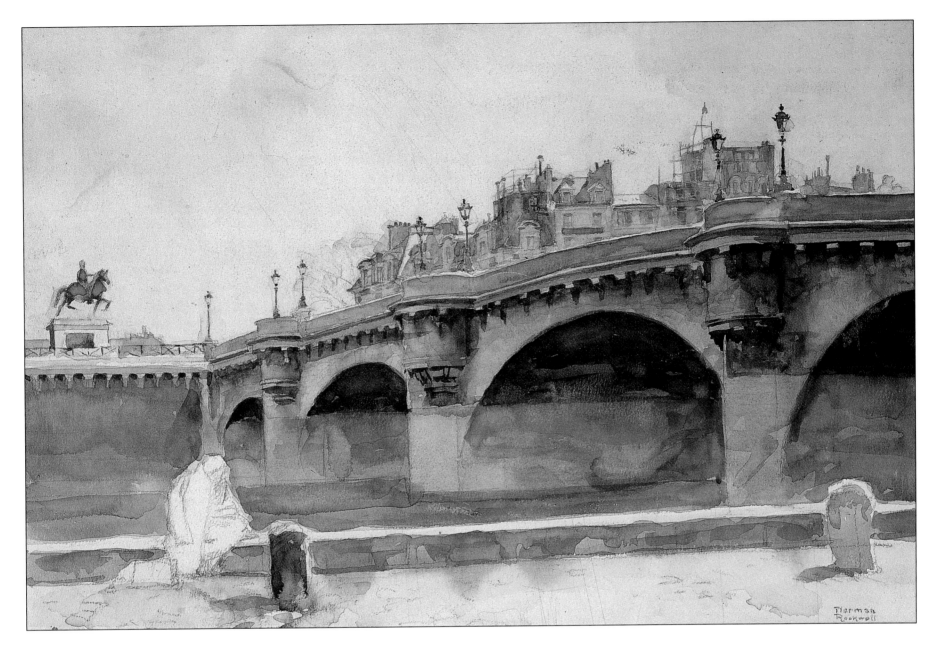

Paris Bridge
Pencil and watercolor on paper
9.375 × 14.25 inches (24 × 36cm)
1932

Rockwell's travels often took him to Europe, particularly England and France. The sketches he did along the way are charming and alive. Although much of Rockwell's work was done in oil, this European travel sketch shows the delicate touch he had with watercolor.

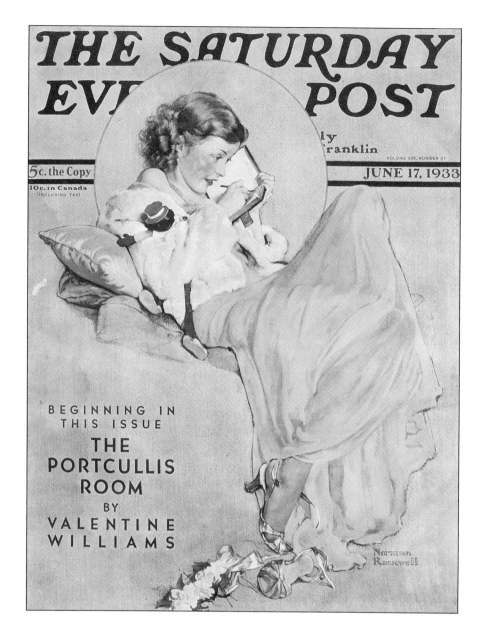

Girl Writing in Diary

1933

Rockwell's women—even the glamorous and sophisticated ones—have a girl-next-door quality.

Spirit of Education

Oil on canvas
32 × 24 inches (81 × 61cm)
1934

This *Post* cover is very typical of the work Rockwell produced during the Depression era. His illustrations at this time were escapist and were designed purely for the viewers' pleasure.

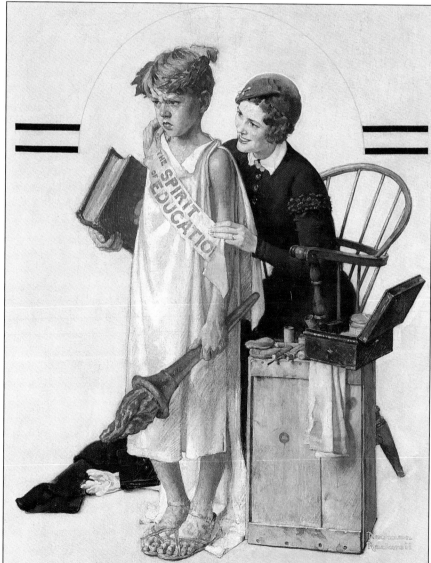

Brass Merchant

Oil on canvas
34 × 28 inches (86 × 71cm)
1934

Inspired by the works of other illustrators and artists, Rockwell often adapted ideas and techniques he appreciated. Of particular note in *Brass Merchant* is a technique he discovered during a trip to Paris—allowing the underdrawing to show through a very light application of paint.

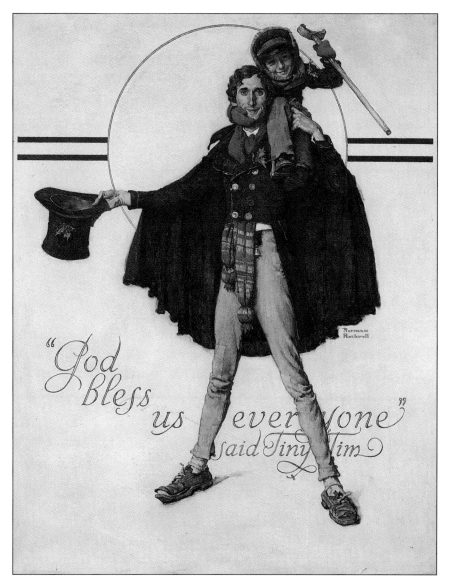

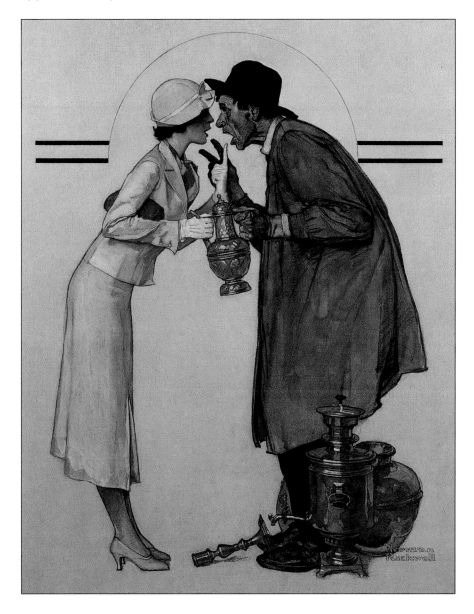

Tiny Tim and Bob Cratchit

Oil on canvas
55 × 31 inches (140 × 79cm)
1934

In this picture, one of his twenty-nine Christmas covers for *The Saturday Evening Post,* Rockwell again uses Dickens characters for a holiday theme.

Boy With Coke, Fishing
1935

Rockwell painted five calendar illustrations for Coca-Cola, which were also used as magazine ads in the early 1930s.

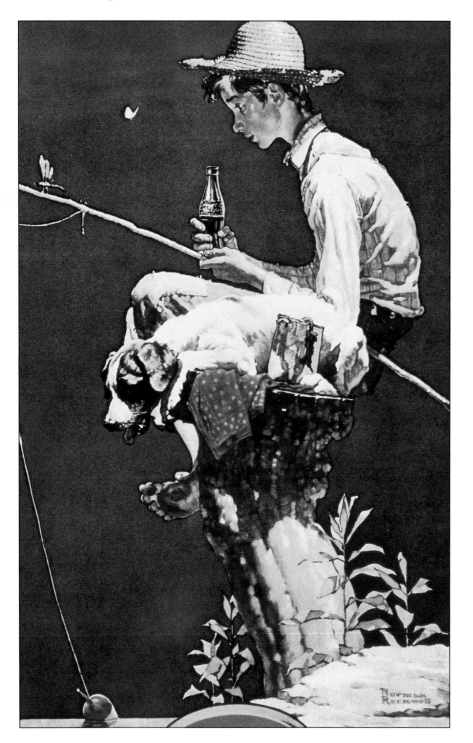

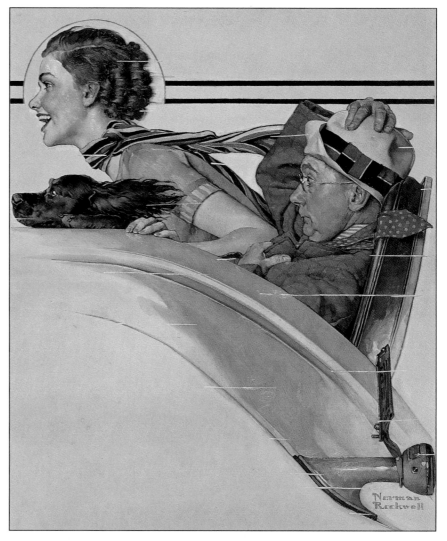

Couple in Rumble Seat
Oil on board
21 × 17.25 inches (53 × 44cm)
1935

A joyride with pals in a rumble seat was an exciting new pastime in 1935. This *Saturday Evening Post* cover uses a favorite Rockwell device—juxtaposing different reactions to the same event. The horizontal lines in the picture increase the sensation of speed.

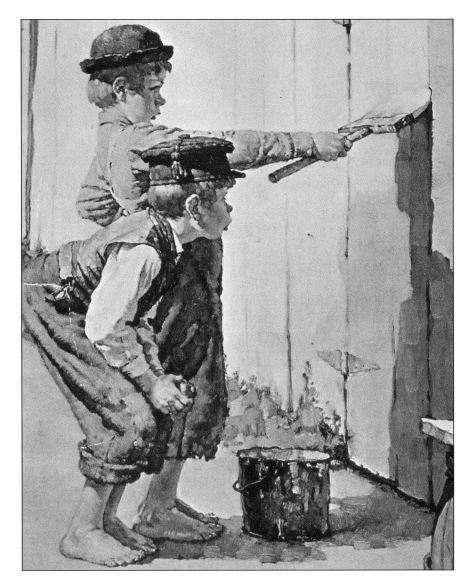

Tom Sawyer Whitewashing the Fence
Oil on canvas
17.5 × 13.75 inches (44 × 35cm)
1936

Rockwell captured the adventures of Tom Sawyer in pictures for a 1936 edition of Mark Twain's classic. Since Twain had used actual places in Hannibal, Missouri, for his novels, Rockwell visited this famed town so that his illustrations would reflect not only Twain's words, but also the character of the town and its occupants.

Barbershop Quartet
Oil on canvas
36 × 27.25 inches (91 × 69cm)
1936

We can almost hear these four gentlemen harmonizing an old favorite—"Sweet Adeline," perhaps?

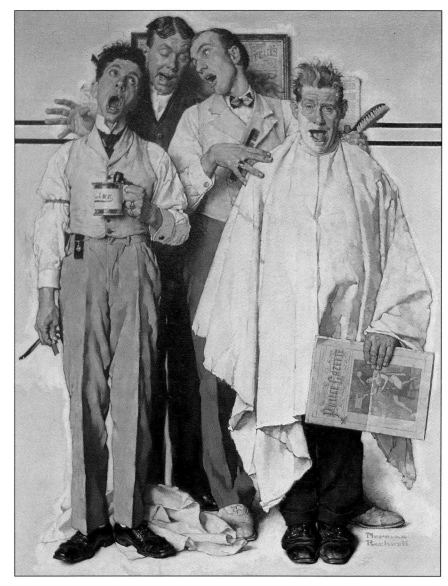

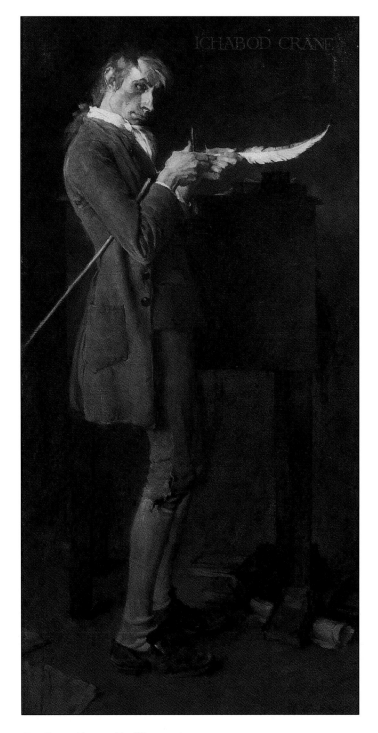

Deadline

Oil on canvas
38.5 × 30.5 inches (98 × 77cm)
1938

Rockwell created 321 covers for *The Saturday Evening Post*. In this self-portrait cover, he capitalizes on the idea of not having an idea. The conceptual sketches and reference books strewn about accurately depict part of Rockwell's creative process.

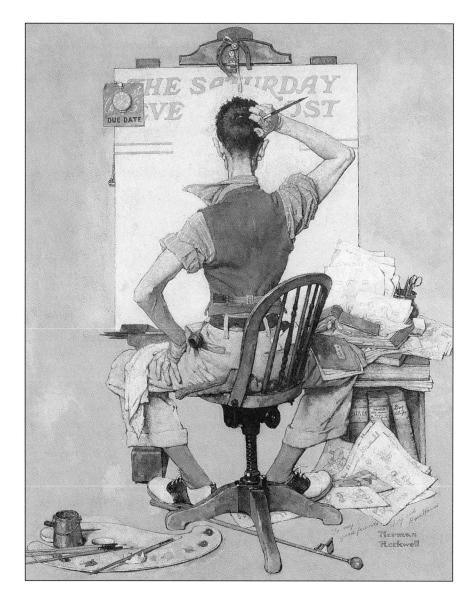

Ichabod Crane

Oil on canvas
38 × 24 inches (97 × 61cm)
c. 1937

During the late 1930s, Rockwell worked on a series of illustrations of major characters in American literature. Although several canvases were finished, the series was never completed.

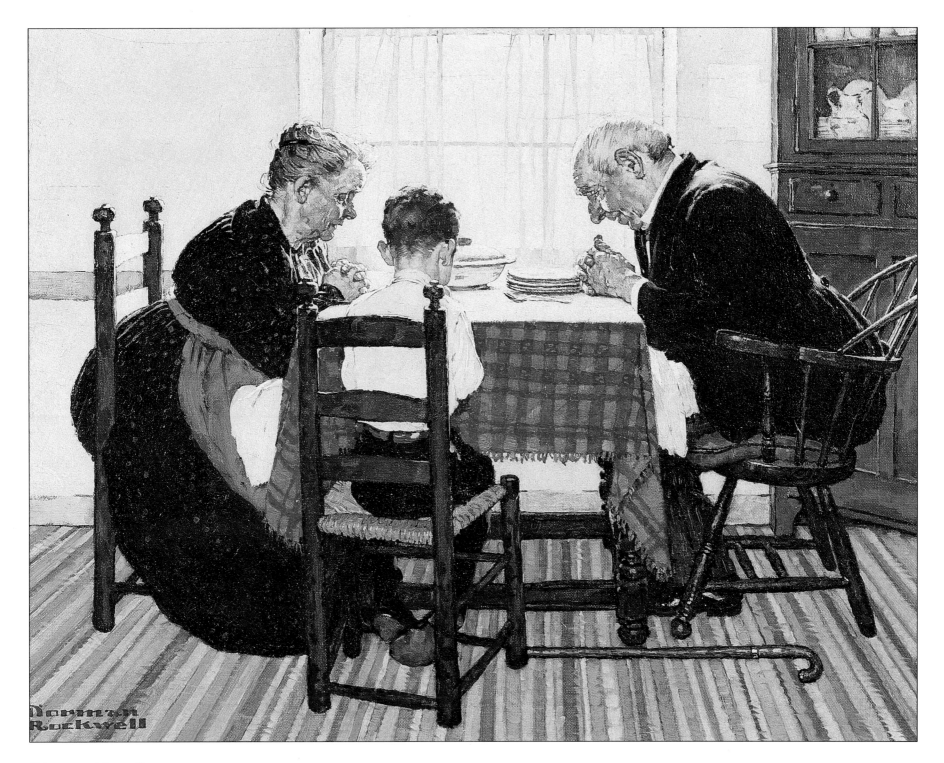

Family Grace
Oil on canvas
16 × 20 inches (41 × 51cm)
1938

Norman Rockwell's images that explore the bonds between generations, such as
this story illustration, are among his most cherished works.

Football Hero

Oil on canvas
30 × 24 inches
(76 × 61cm)
1938

Although Rockwell
himself was neither an
athlete nor a scholar, his
ability to draw allowed
him to create real and
endearing characters
capable in each of
those areas.

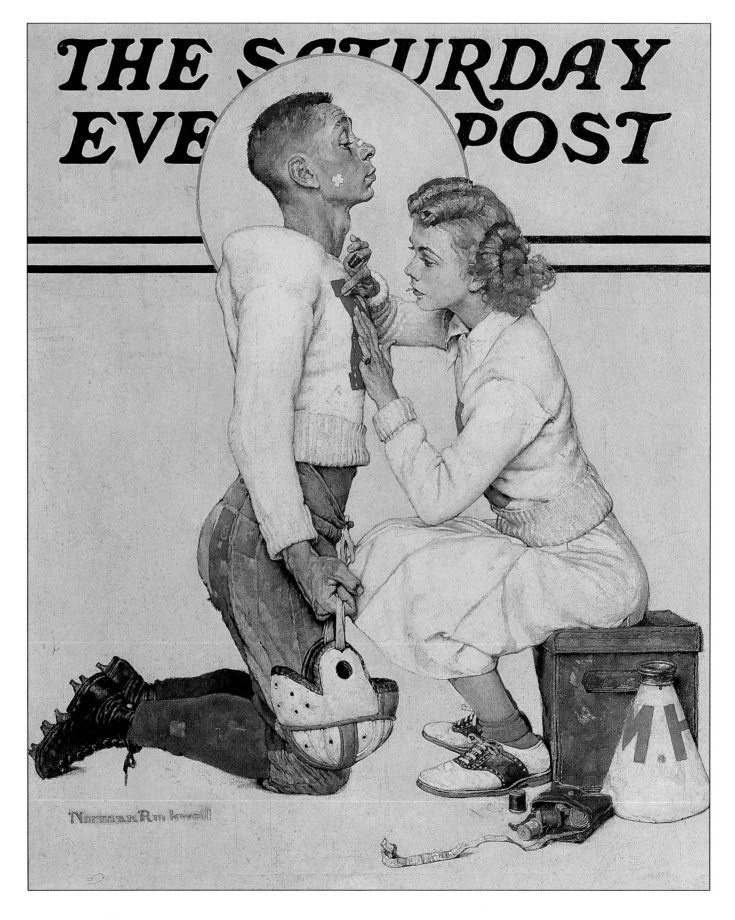

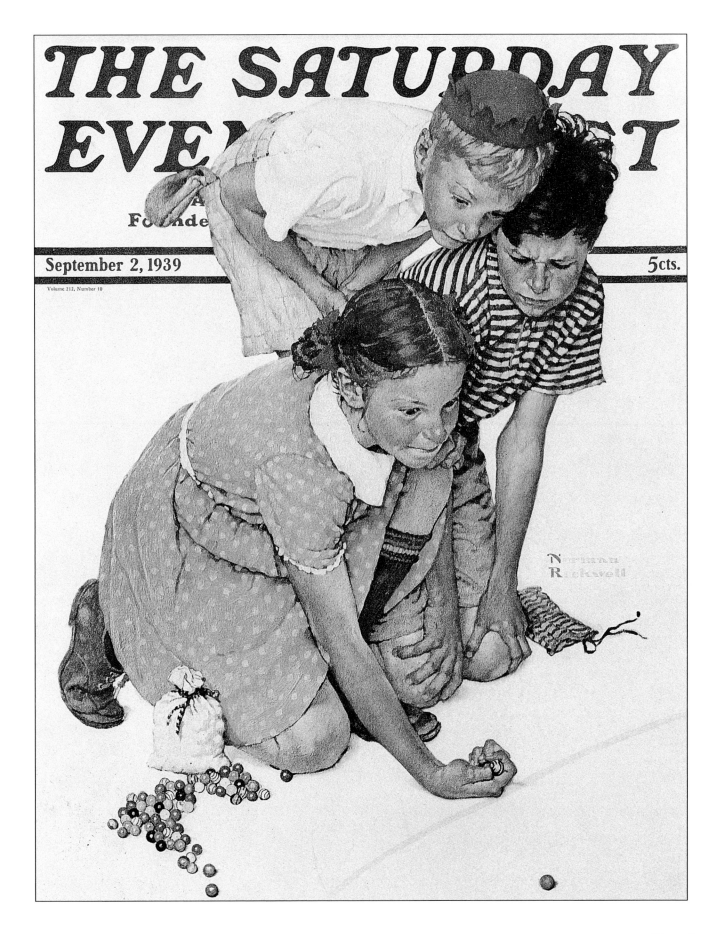

Marble Champion

Oil on canvas
28 × 22 inches
(71 × 56cm)
1939

Rockwell's ability to tell stories depended, in part, on his providing just the right twist to keep readers interested. Here, the girl's marble-shooting prowess—and the boys' surprise—is the necessary "hook."

Extra Good Boys and Girls

Oil on canvas
37 × 29 inches
(94 × 74cm)
1939

Rockwell Santas became the personification of what Americans believed Santa should look like—round and jovial.

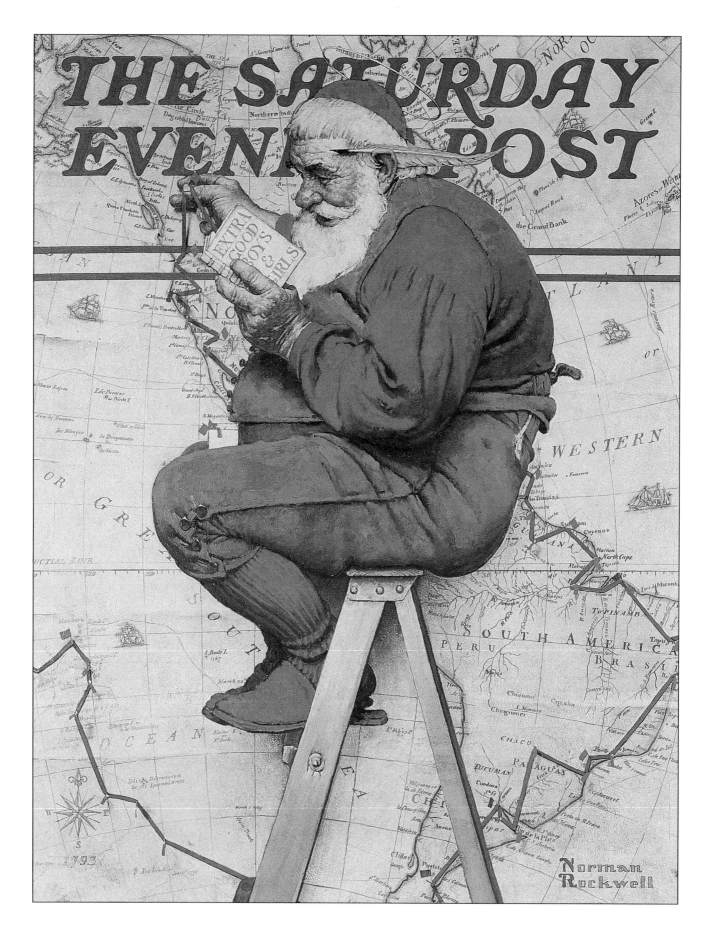

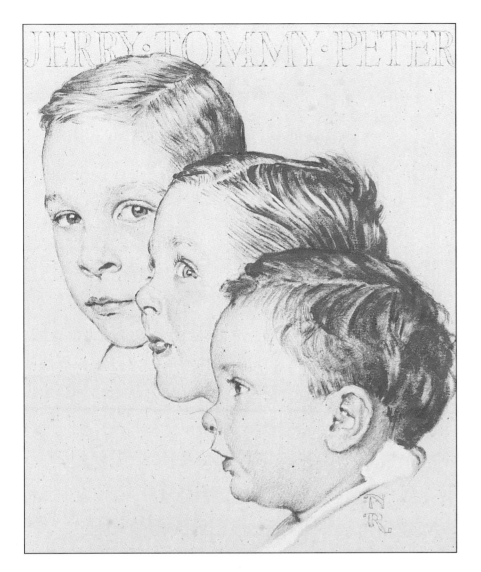

Portrait of Jerry, Tommy and Peter Rockwell
Pastel on paper
11 × 9.25 inches (28 × 23cm)
1939

Rockwell and his wife, Mary, had three sons: Jarvis, an abstract artist; Thomas, an author; and Peter, a sculptor and teacher.

Huck Finn Praying in the Closet
Charcoal on paper
17 × 13.5 inches (43 × 34cm)
1940

For his illustrations for *The Adventures of Huckleberry Finn,* Rockwell spent an afternoon in Hannibal, Missouri, buying old clothes from townspeople for his models to wear. The next morning he discovered a crowd of people outside his hotel. The local newspaper had reported that there was a "crazy man in Hannibal buying old clothes for high prices."

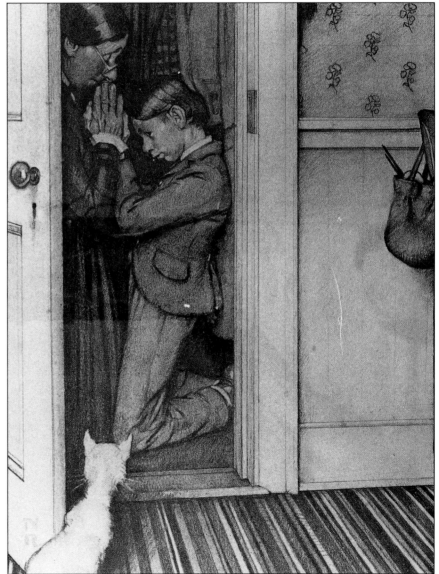

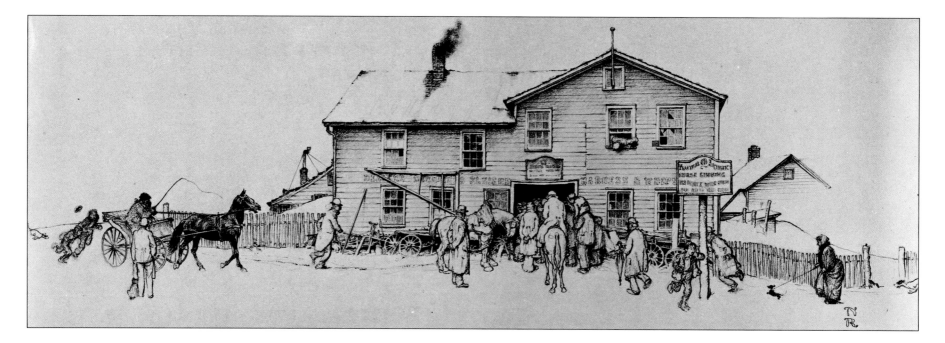

The Blacksmith Shop

Charcoal on paper
10 × 28 inches
(25 × 71cm)
1940

By showing the backs and profiles of people, a technique he used frequently, Rockwell draws the viewer into the goings-on in this story illustration.

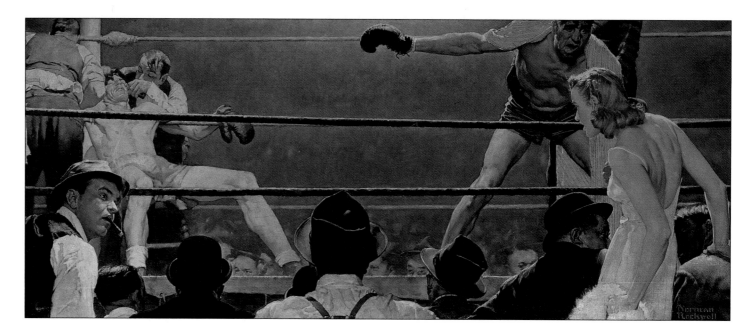

Strictly a Sharpshooter

Oil on canvas
30 × 71 inches (76 × 180cm)
1941

Research for this picture led Rockwell to spend time in a boxing club in Manhattan to study characters. The people who ultimately modeled for him were neighbors from Arlington; although cast completely against type, they successfully contribute to the picture's atmosphere.

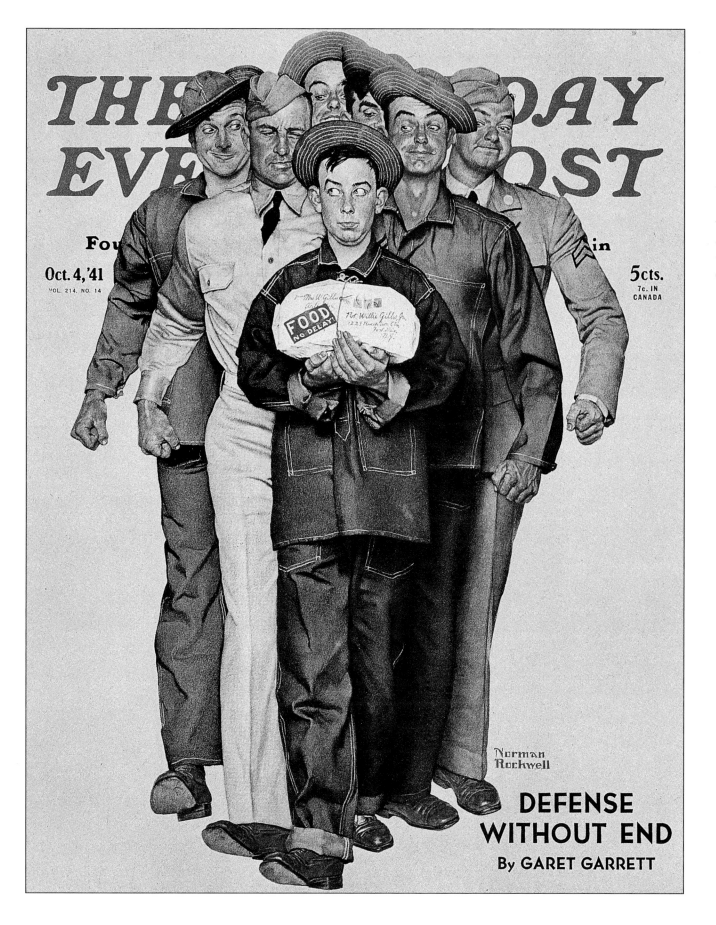

Willie Gillis: Food Package
1941

This was the first of eleven *Saturday Evening Post* covers that represented a running narrative of the war years through the experiences of Willie Gillis, the "everyman" G.I. whom Rockwell invented.

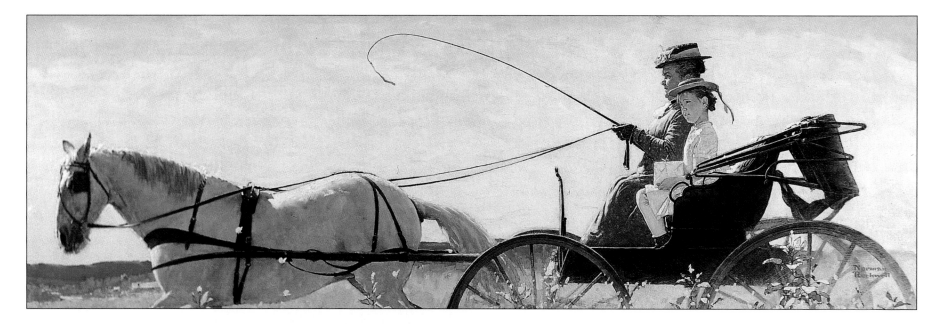

Aunt Ella Takes a Trip
Oil on canvas
60 × 23 inches (152 × 58cm)
1942

Rockwell usually allowed the background and animals in his pictures to support the people who were the focus. In this story illustration for *Ladies Home Journal,* Aunt Ella and her young niece seem very much supported by their horse and cart and the setting through which they travel.

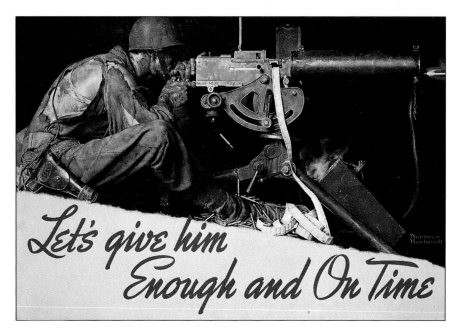

Let's give him Enough and On Time
Oil on canvas
42 × 50 inches (107 × 127cm)
1942

While Willie Gillis offered an innocent perspective on World War II, this powerful picture, Rockwell's first World War II poster, is a reminder about the true nature of war.

FOUR FREEDOMS

Inspired by Franklin Delano Roosevelt's 1941 speech, Norman Rockwell created *The Four Freedoms* as his contribution to the war effort. Published by *The Saturday Evening Post* in 1943, the paintings then were the focus of a nationwide tour that helped raise more than $132 million through sales of war bonds.

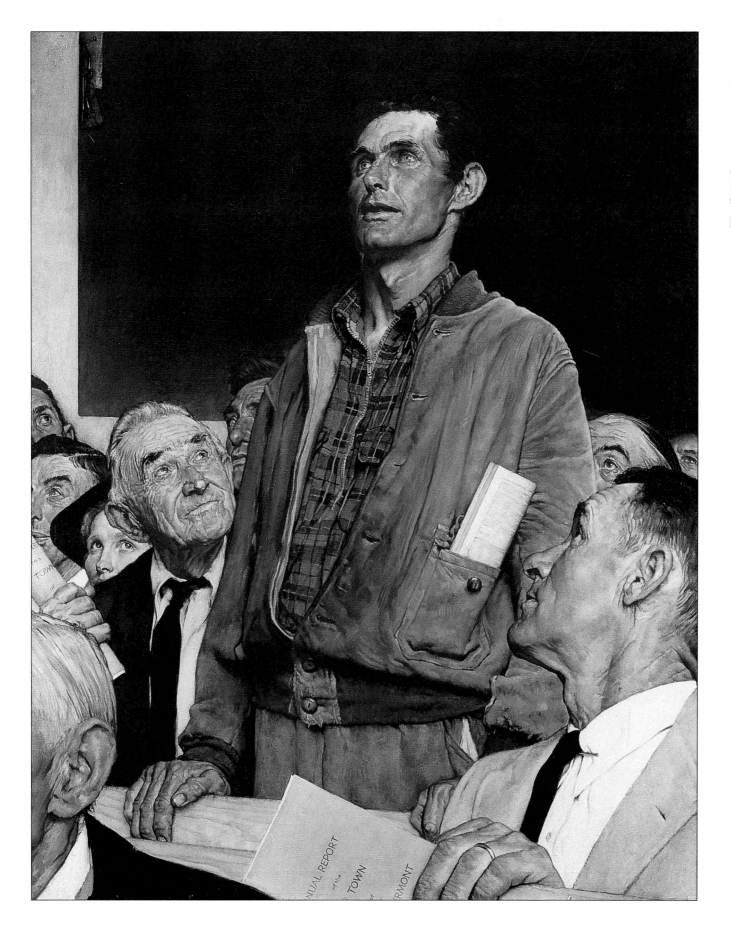

Freedom of Speech

Oil on canvas
45.75 × 35.5 inches
(116 × 90cm)
1943

A citizen exercises his right to speak freely at a town meeting—and people are listening.

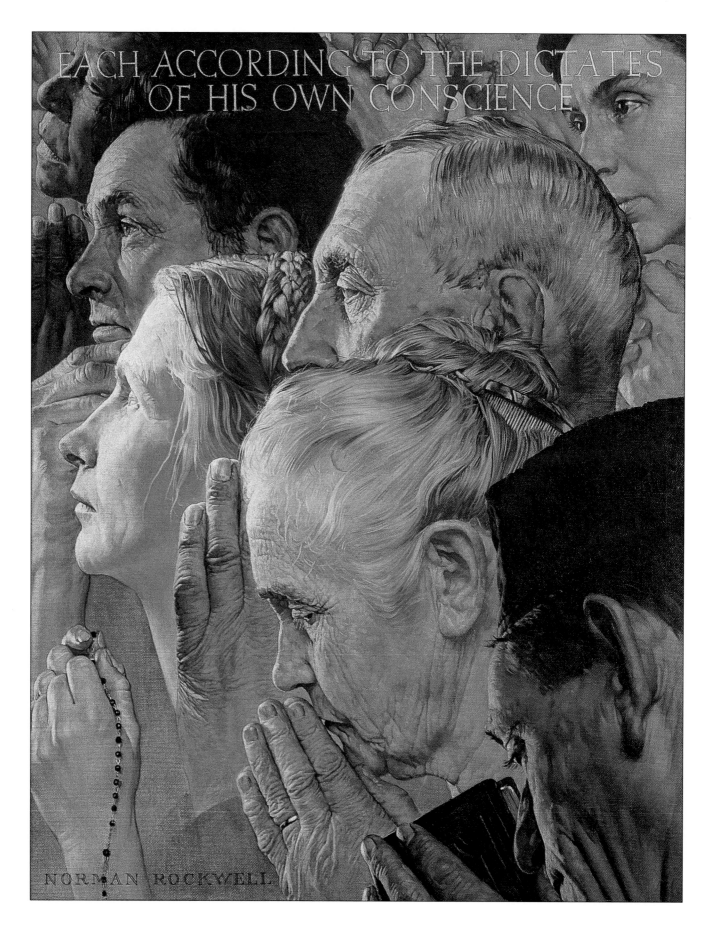

Freedom to Worship

Oil on canvas
46 × 35.5 inches
(117 × 90cm)
1943

A beautiful and loving study of hands and faces in attitudes of reverence, "each according to the dictates of his own conscience."

EACH ACCORDING TO THE DICTATES OF HIS OWN CONSCIENCE

NORMAN ROCKWELL

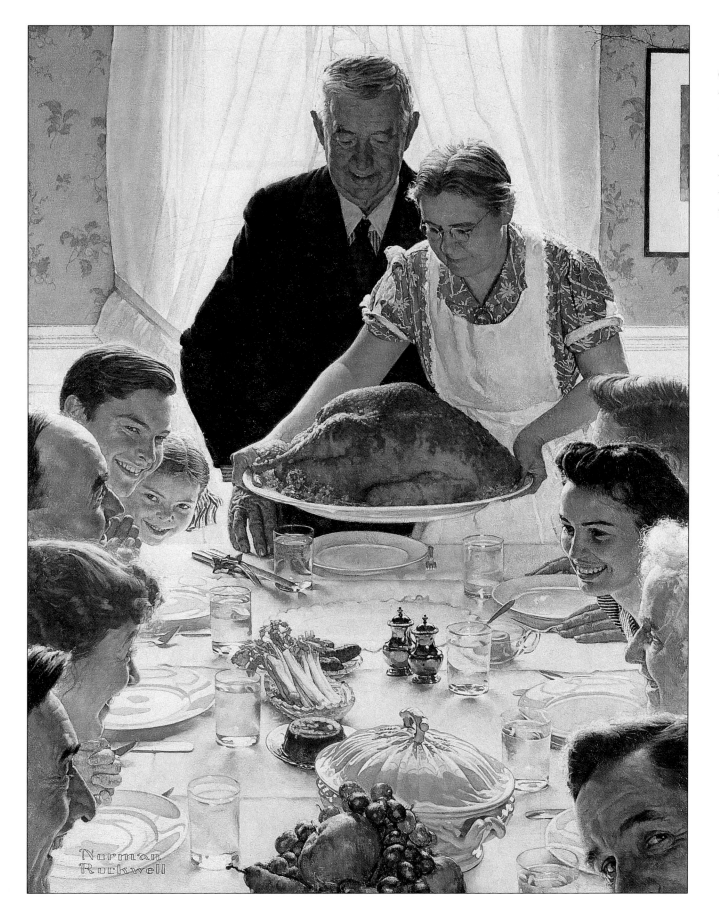

Freedom From Want

Oil on canvas
45.75 × 35.5 inches
(116 × 90cm)
1943

The open end of the table invites the viewer to sit down and share in this freedom.

Freedom
From Fear

Oil on canvas
45.75 × 35.5 inches
(116 × 90cm)
1943

The headline on the
newspaper provides a
stark contrast to the
warmth and security this
family portrays.

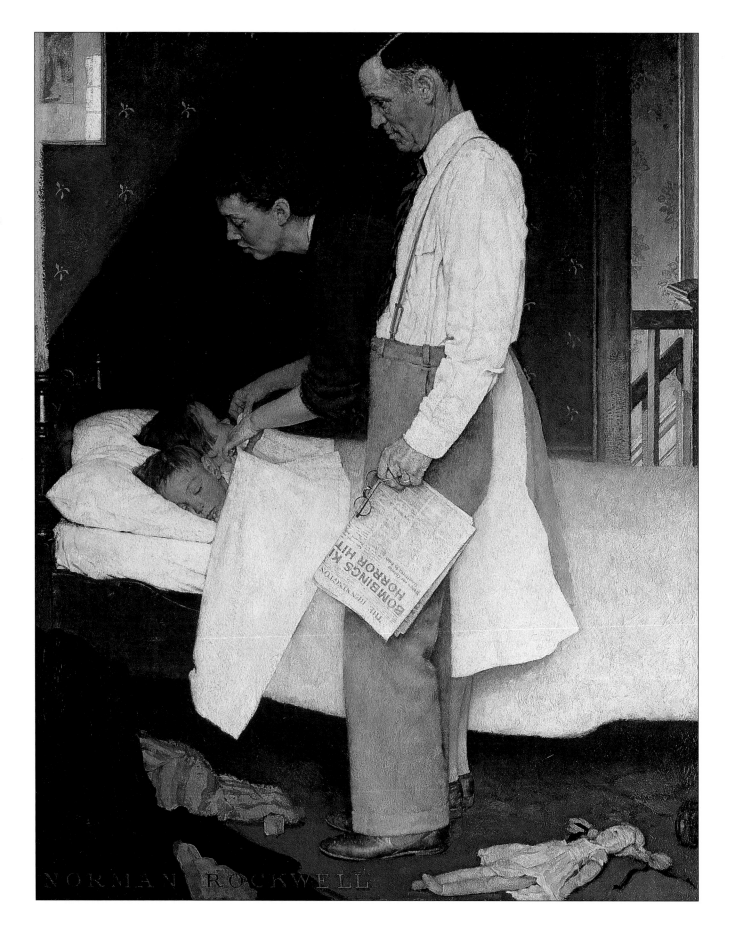

Mine America's Coal

Oil on canvas
21 × 14 inches (53 × 36cm)
1943

In this poster illustration, Rockwell continues to focus on stateside workers during World War II. The stars on this miner's shirt represent his two sons who are fighting overseas.

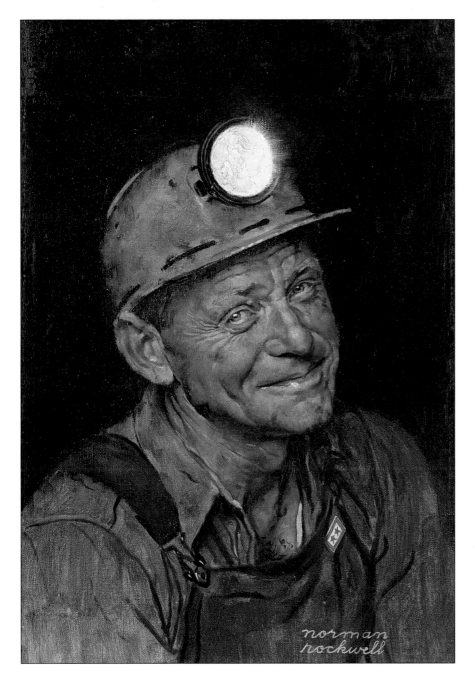

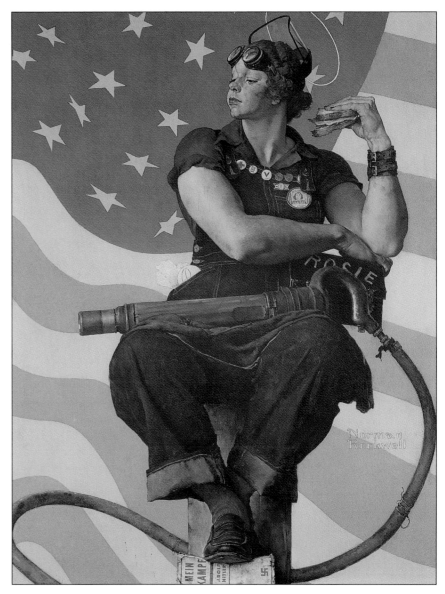

Rosie the Riveter

Oil on canvas
52 × 40 inches (132 × 102cm)
1943

A symbol of the women whose work was critical to war production, Rosie is posed in a position reminiscent of that of the prophet Isaiah in Michelangelo's Sistine Chapel mural.

My Studio Burns

Charcoal on paper
21.5 × 17 inches
(55 × 43cm)
1943

In 1943, Rockwell's studio in Arlington caught fire and burned to the ground, an event that he chronicled with bittersweet humor in this drawing. "In a way the fire was a good thing," he said. "It cleaned out a lot of cobwebs."

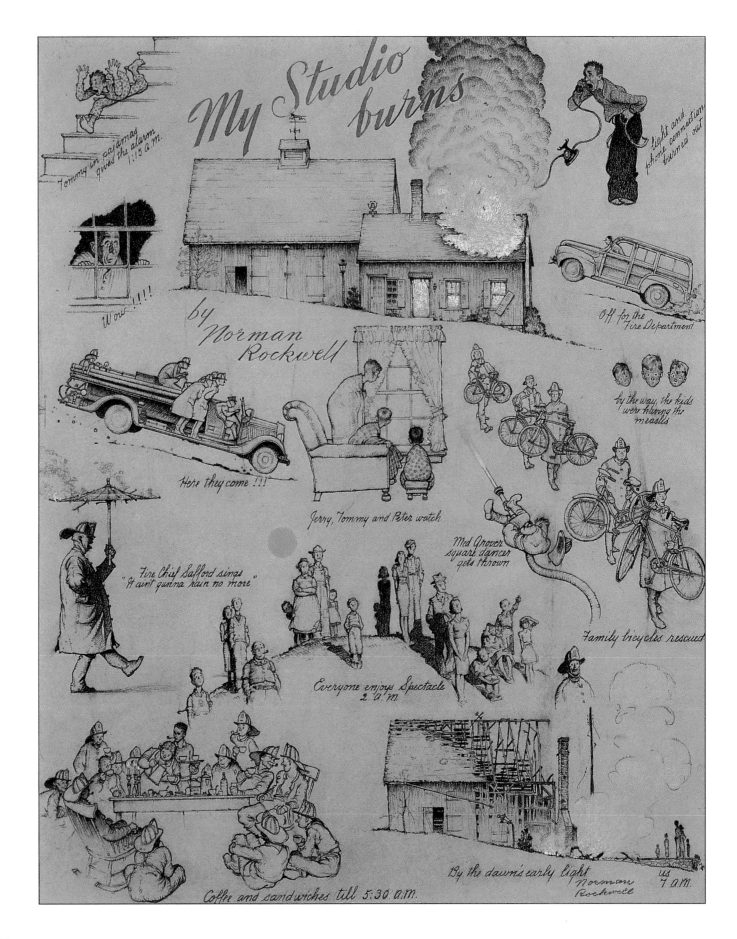

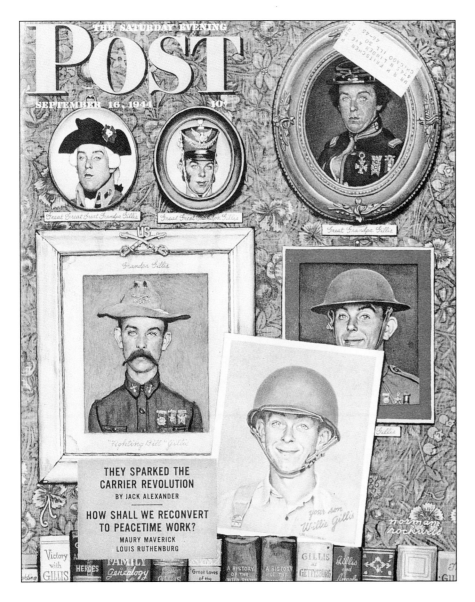

Willie's Ancestors
Oil on board
13.25 × 10.625 inches (34 × 27cm)
1944

This was one of the last Willie Gillis covers to appear. Since the young man who had posed for Willie, Bob Buck, had enlisted in the Navy and was no longer available to pose, Rockwell used photographs of him that were taken earlier to create the six generations of Gillis soldiers.

Which One?
1944

The themes of elections and decision-making are common to many Rockwell pictures. In the presidential election of 1944, Franklin Delano Roosevelt was reelected for a fourth term.

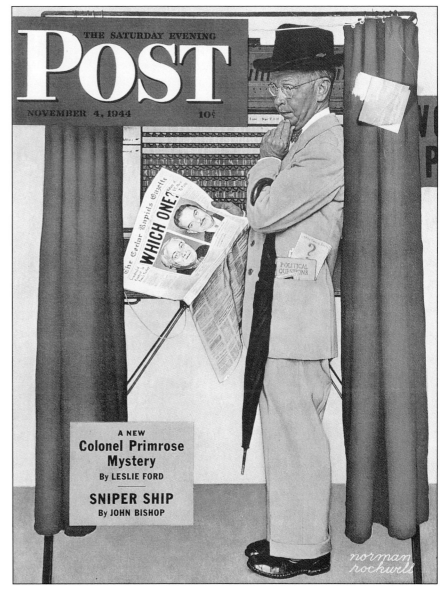

War News

Oil on canvas
41.25 × 40.5 inches (105 × 103cm)
c. 1945

Although never published as a *Post* cover, this
painting has become one of Rockwell's best-
known wartime works. During World War II, radio
brought the sounds of the battle directly to the
home front for the first time.

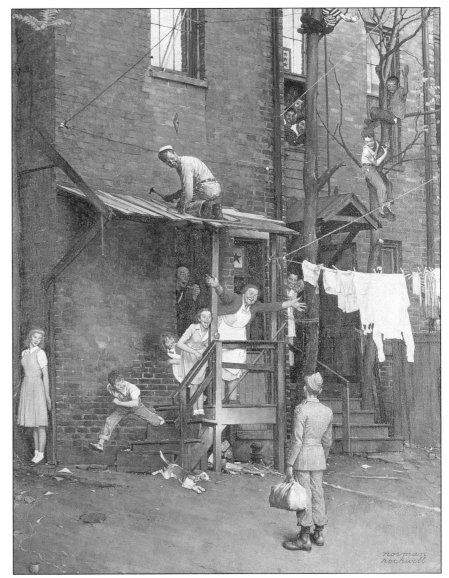

The Homecoming

Oil on canvas
28 × 22 inches (71 × 56cm)
1945

Rockwell captured the spirit in America as the
troops returned home to the enthusiasm of their
families and neighbors in 1945.

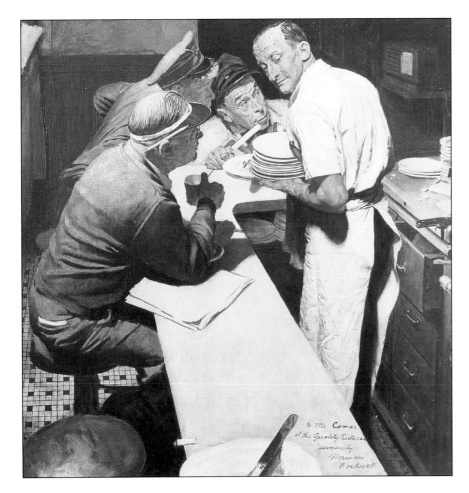

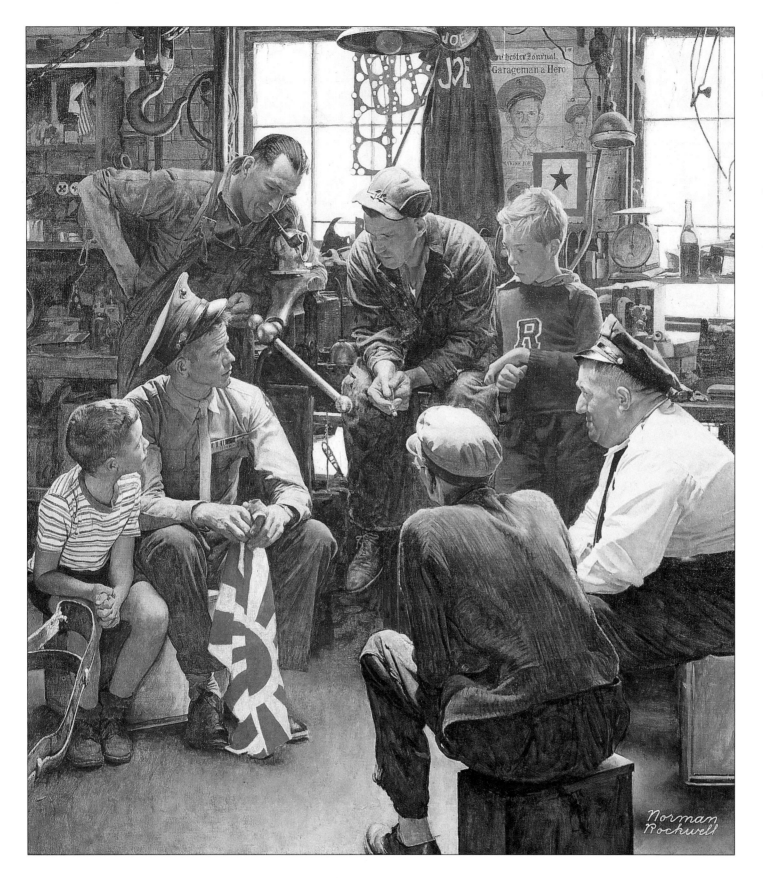

Homecoming Marine

Oil on canvas
46 × 42 inches
(117 × 107cm)
1945

Rockwell portrayed soldiers returning from World War II with proud stories of heroism to share with peers. Notice the newspaper clipping on the wall of the garage in this picture. By including this detail, along with the Japanese flag in the soldier's hand, Rockwell tells us everything we need to know about who the soldier is and where he has been.

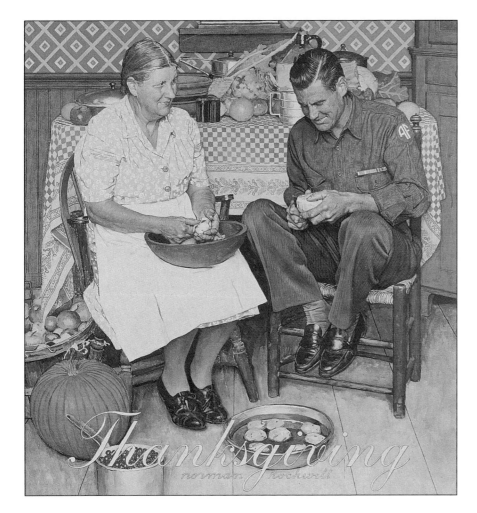

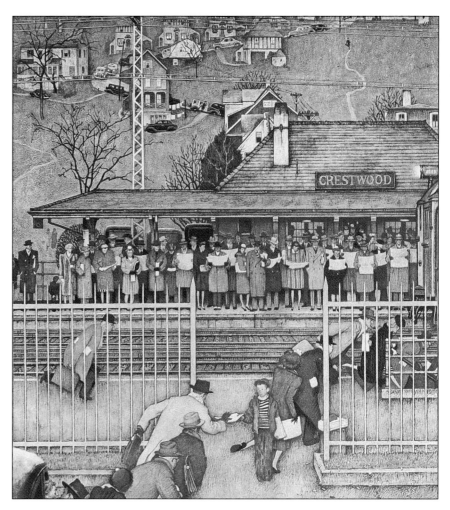

Thanksgiving
Oil on canvas
35 × 33.5 inches (89 × 85cm)
1945

This was the first Thanksgiving cover to appear on the *Post* after the end of World War II. Only a few days before the deadline for this picture, Rockwell found that he was displeased with his original idea; he then created this piece in just three days' time.

Crestwood Commuter Station
Oil on canvas on board
22 × 20.5 inches (56 × 52cm)
1946

The growth of the suburbs and the increase in the number of commuters are two of the postwar trends highlighted in this *Post* cover.

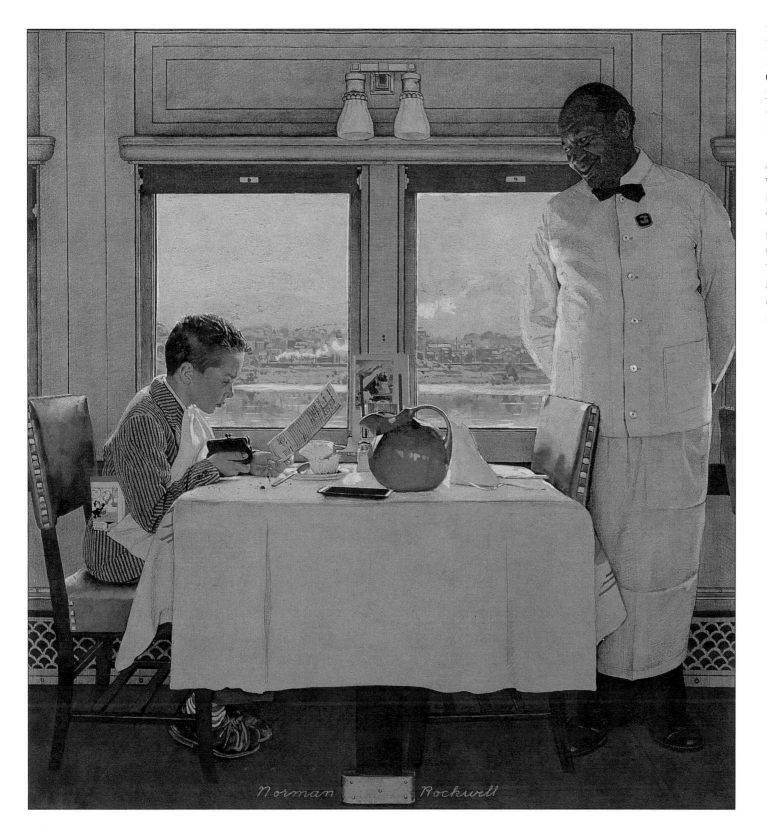

Boy in Dining Car

Oil on canvas
38 × 36 inches
(97 × 91cm)
1946

Authenticity of detail was very important to Rockwell. He often visited actual sites to get his interiors and exteriors just right. For this picture, he arranged for a dining car to be sidetracked at New York's train yard.

Going and Coming

Oil on canvas
Upper canvas: 16 × 31.5
inches (41 × 80cm)
Lower canvas: 16 × 31.5
inches (41 × 80cm)
1947

This unique two-part
Post cover tells a
complete story. Some
changes between the
two panels are obvious
and some are subtle,
but all contribute to the
telling of the story. Note
Grandma in the back
seat.

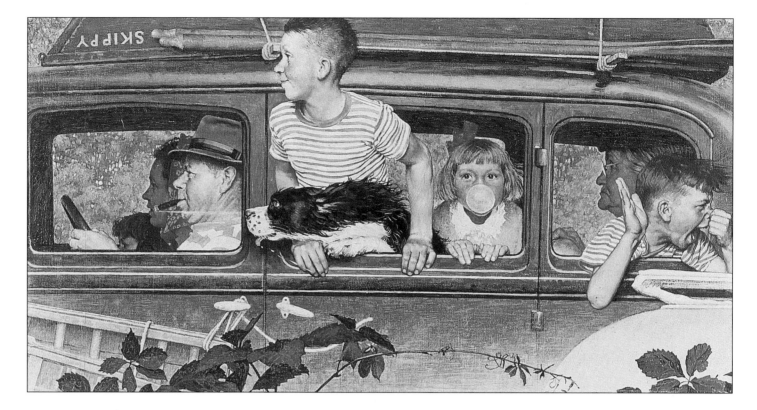

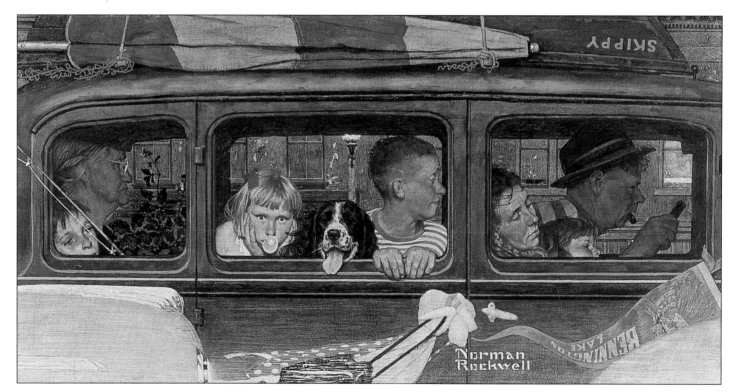

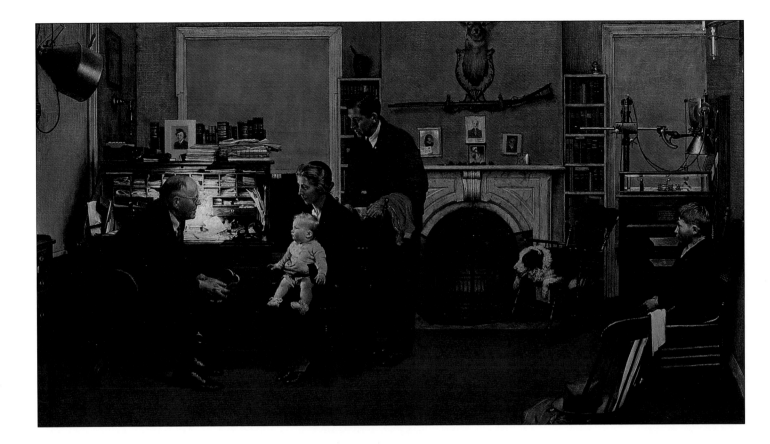

Norman Rockwell Visits a Family Doctor

Oil on canvas
32 × 60 inches
(81 × 152cm)
1947

The Rockwell family doctor's office is the site of this picture. Dr. George Russell, who with his dog, Bozo, modeled for Rockwell, was well known to his patients in Arlington as a man of great warmth and devotion.

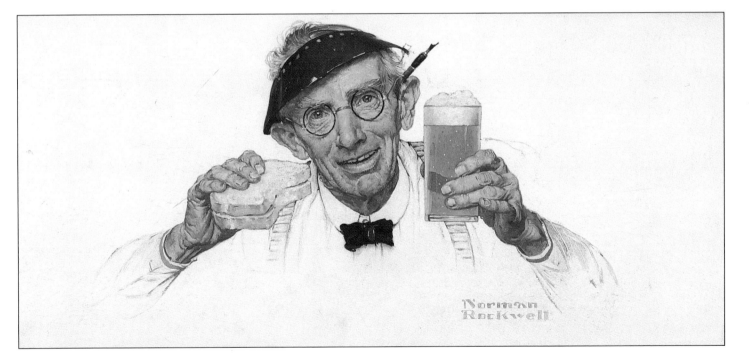

Man With Sandwich and Glass of Beer

Oil on board
14 × 30.5 inches
(36 × 77cm)
1947–1950

While other types of illustrations formed the majority of Rockwell's commissions through the 1940s, he continued to do advertising work, such as this ad for Ballantine Beer.

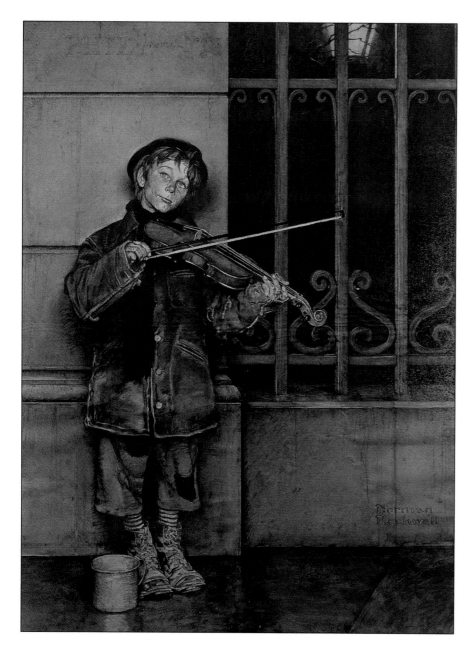

Phil the Fiddler
Charcoal on paper (study)
41 × 30 inches (104 × 76cm)
c. 1948

The charcoal studies that Rockwell did for each picture, such as that of this Horatio Alger character, which was never published, can often be considered works of art in and of themselves.

Christmas Homecoming
Oil on canvas
35.5 × 33.5 inches (90 × 85cm)
1948

The whole Rockwell family appears in this 1948 *Post* cover. Mary Rockwell (in the yellow dress) embraces son Jarvis, while Norman, middle son Thomas (in the plaid shirt), and youngest son Peter (on the far left) look on. Grandma Moses and the illustrator Mead Schaeffer also appear.

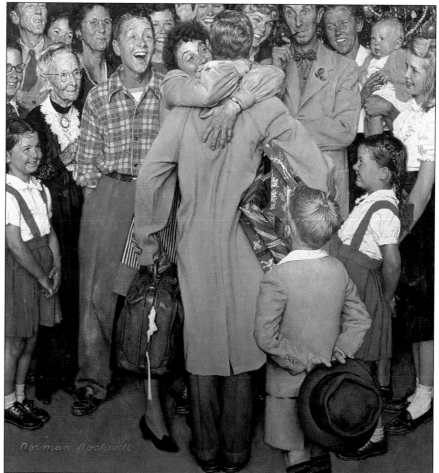

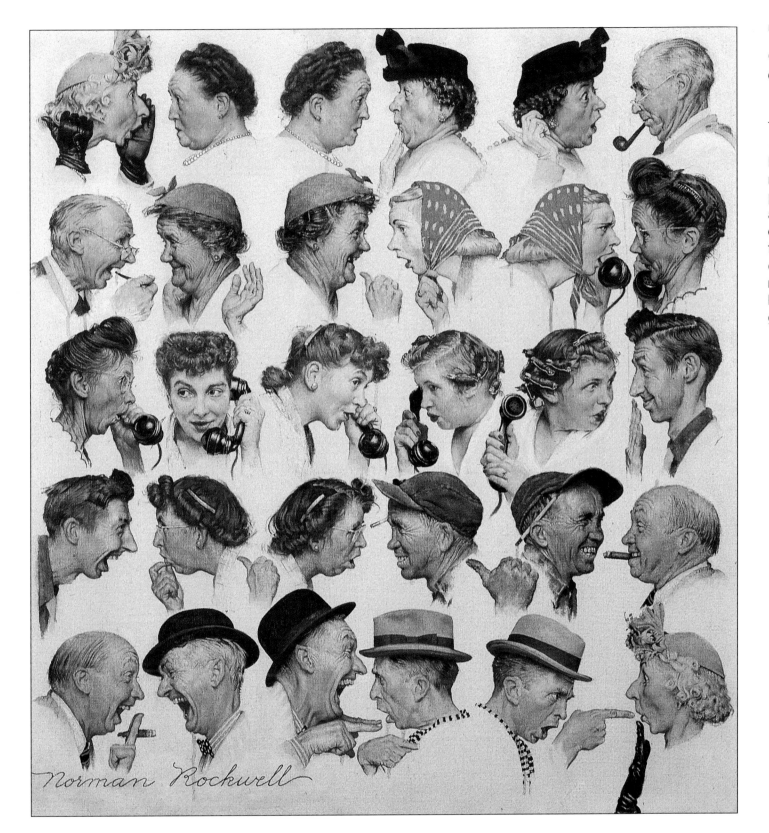

The Gossips

Oil on canvas
1948

The subjects in *The Gossips* were Rockwell's Vermont neighbors. By incorporating both himself and wife, Mary, as part of the picture, Rockwell tried to avoid the displeasure of his neighbors/models at being portrayed as gossips.

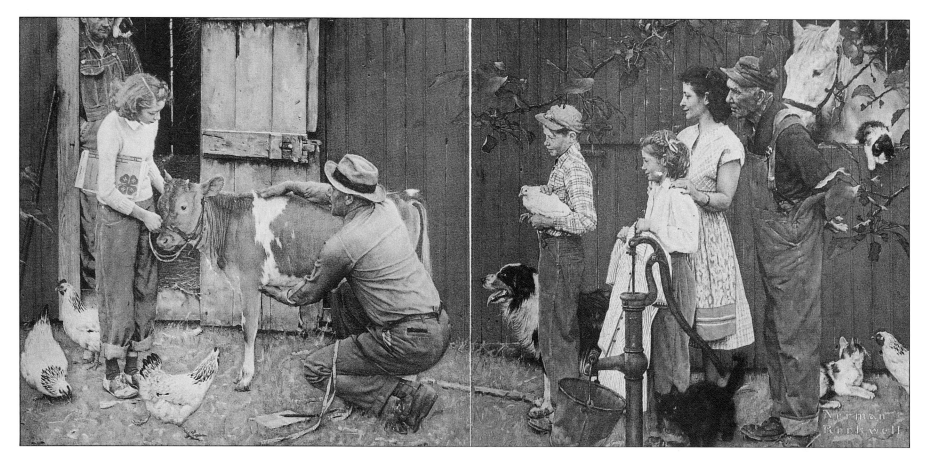

Norman Rockwell Visits a County Agent

Oil on canvas
36.25 × 70 inches (92 × 178cm)
1948

Part of a series of *Norman Rockwell Visits* pictures done for the *Post*, Rockwell's focus on the young 4-H girl and her calf is supported compositionally by the interest of the other parties—both human and animal—in the picture.

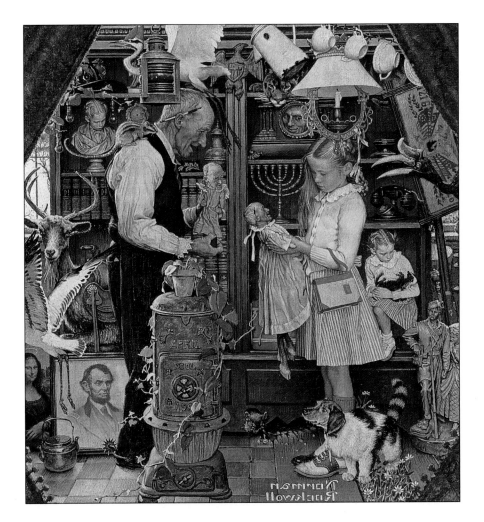

April Fool: Girl With Shopkeeper
1948

Rockwell did three April Fool covers for *The Saturday Evening Post*. While he intentionally incorporated about fifty errors in these pictures, enthusiastic *Post* readers sometimes identified as many as two hundred.

New Television Antenna
Oil on canvas
46.5 × 43 inches (118 × 109cm)
1949

The installation of television antennae was a new and remarkable event in 1949.

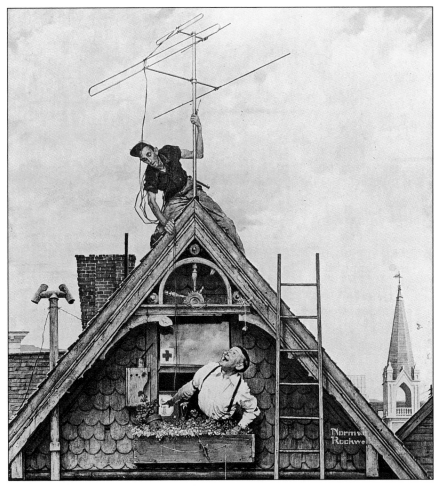

Shuffleton's Barbershop

Oil on canvas
46.25 × 43 inches
(117 × 109cm)
1950

This *Post* cover is an excellent example of Rockwell's use of light and shadow to draw focus to his subject.

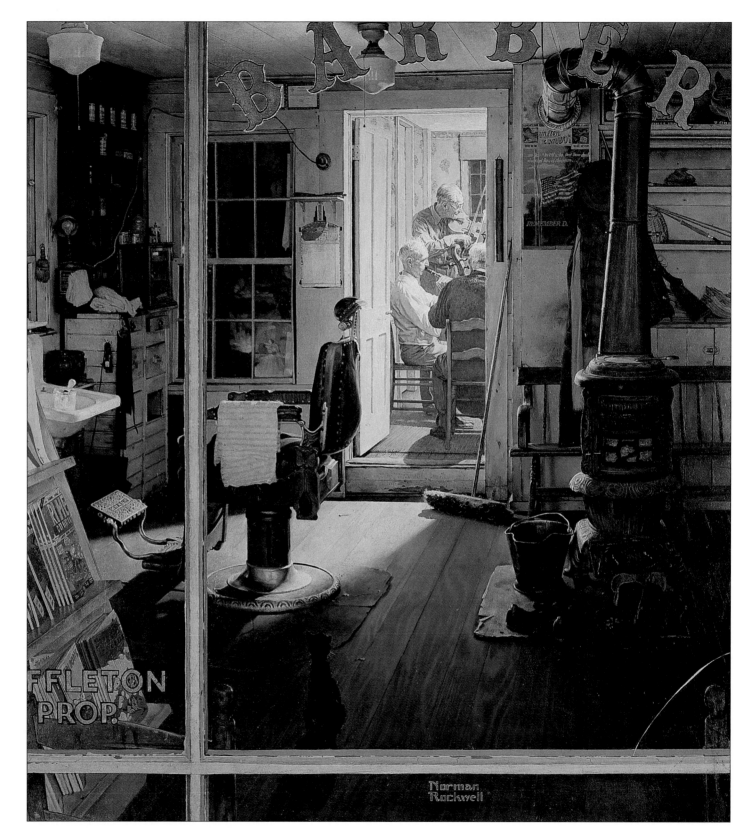

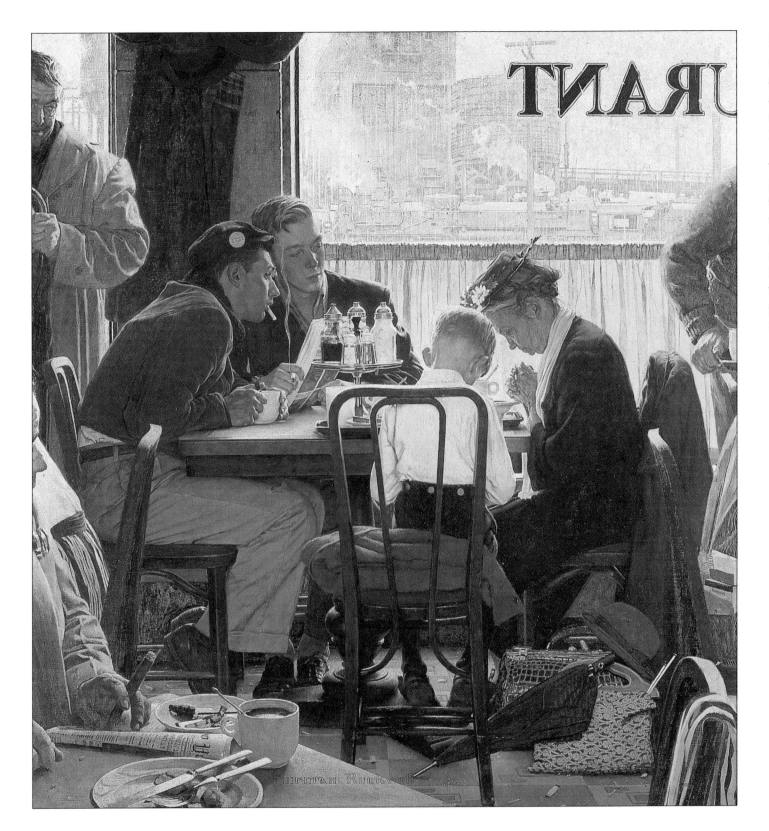

Saying Grace

Oil on canvas
42 × 40 inches
(107 × 102cm)
1951

Two of Norman Rockwell's favorite themes—adherence to values and relationships among generations — are beautifully detailed in this painting, which was done as a Thanksgiving cover for the *Post*.

BROWN & BIGELOW CALENDARS

The annual seasonal calendars Rockwell created during a seventeen-year relationship with Brown & Bigelow provide endearing glimpses of people experiencing the phases of their lives. The *Four Sporting Boys* series, for example, shows the awkwardness of youth through the four seasons. One easily recognizable "sporting boy" character is based on a young Norman Rockwell, who described his eleven-year-old self as a boy who wasn't "God's gift to man in general or the baseball coach in particular. At that age boys who are athletes are expressing themselves fully. They have an identity, a recognized place among the other boys. I didn't have that. All I had was the ability to draw, which as far as I could see didn't count for much. But because it was all I had, I began to make it my whole life. I drew all the time. Gradually my narrow shoulders, long neck, and pigeon toes became less important to me. My feelings no longer paralyzed me. I drew and drew and drew."

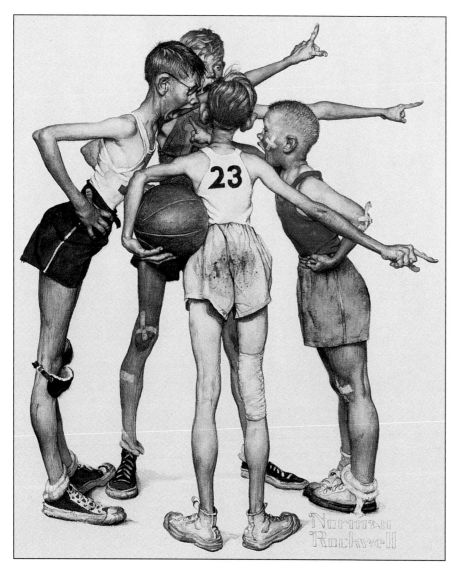

Four Sporting Boys: Basketball
Oil on board
13.5 × 12 inches (34 × 30cm)
1951

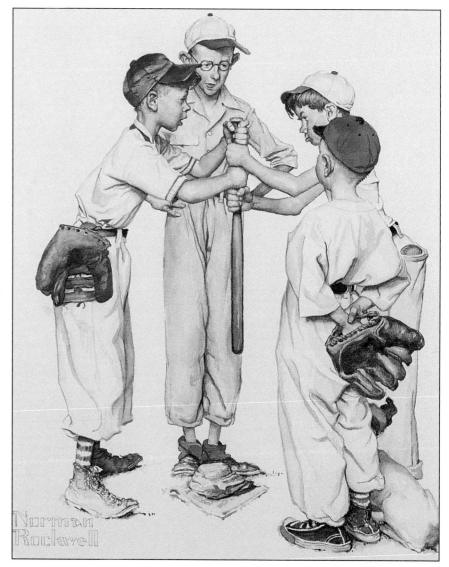

Four Sporting Boys: Baseball
Oil on board
13.5 × 12 inches (34 × 30cm)
1951

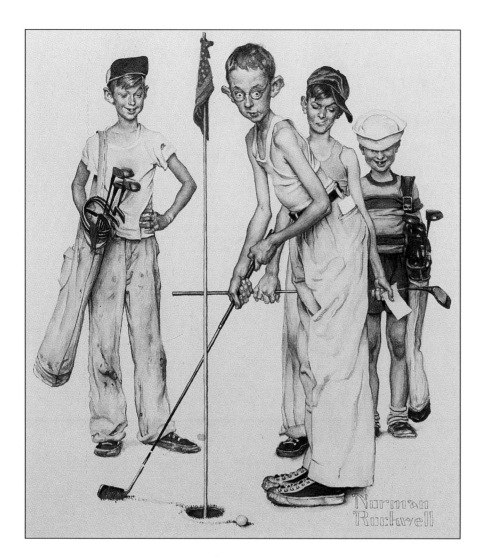

Four Sporting Boys:
Football
Oil on board
13.5 × 12 inches (34 × 30cm)
1951

Four Sporting Boys: Golf
Oil on board
13.5 × 12 inches (34 × 30cm)
1951

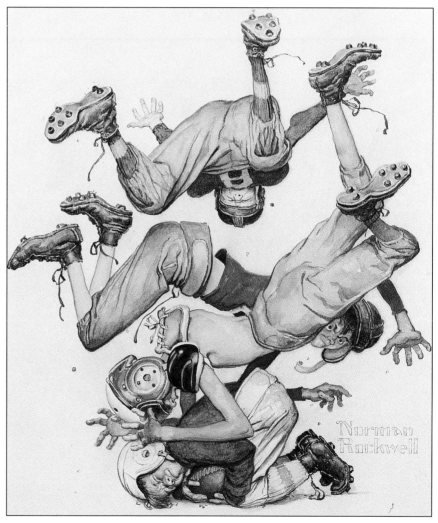

Day in the Life of a Little Girl

Oil on canvas
45 × 42 inches
(114 × 107cm)
1952

Rockwell said of Mary Whalen, seen here in a variety of situations, "She was the best model I ever had. [She] could look sad one minute, jolly the next, and raise her eyebrows until they almost jumped over her head."

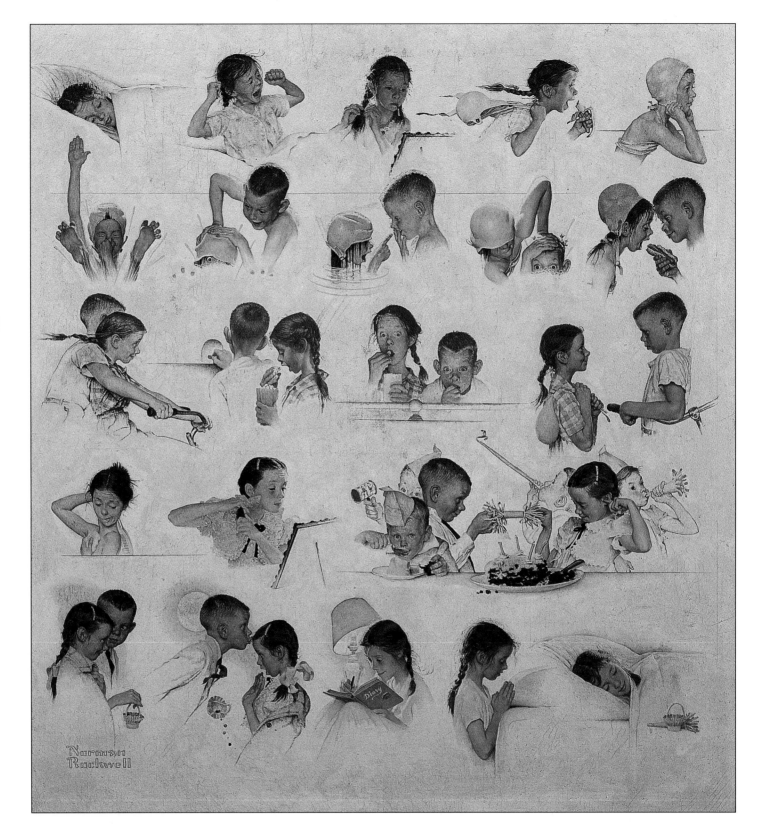

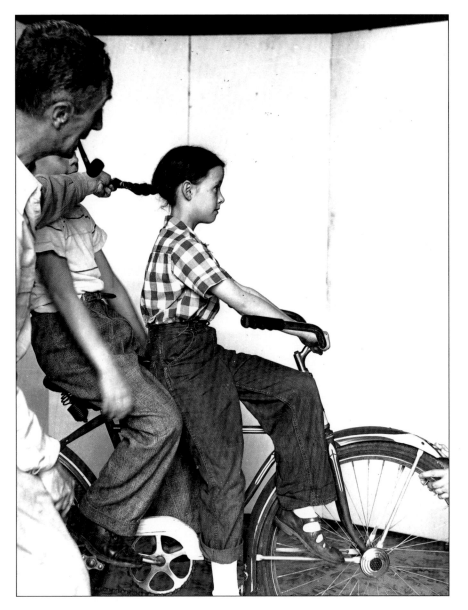

For Day in the Life of a Little Girl, *done in 1952,*
Rockwell used a number of photographs for each of
the vignettes in the picture.

"The Day I Painted Ike"— Dwight D. Eisenhower
Oil on canvas
10 × 8 inches (25 × 20cm)
1952

Rockwell painted portraits of all the major
presidential candidates from 1952 to 1972. A
series of portraits, including this serious study,
was done for a 1952 *Post* article, "The Day I
Painted Ike."

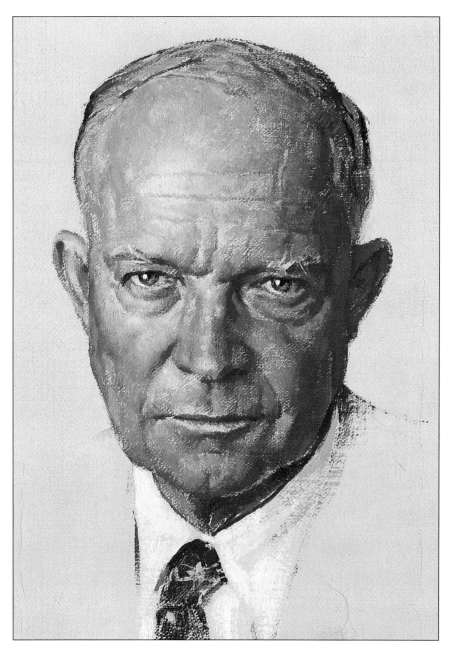

The Street Was Never the Same

Oil, charcoal, and watercolor on canvas (detail)
15 × 14 inches (38 × 36cm)
1953

To celebrate Ford Motor Company's fiftieth anniversary in 1953, Rockwell was commissioned to paint a series depicting the early days of the automobile, as well as portraits of Ford's founders. This comical scene shows the various reactions to the first car in the neighborhood—the facial expressions tell all.

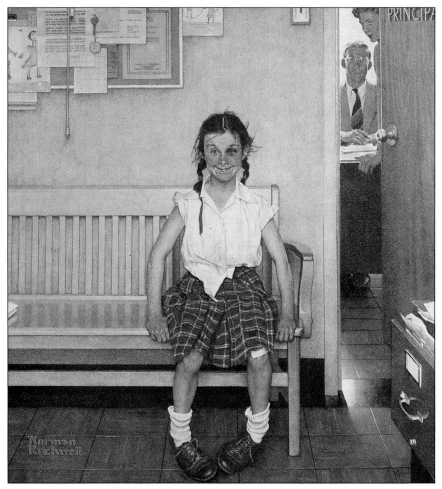

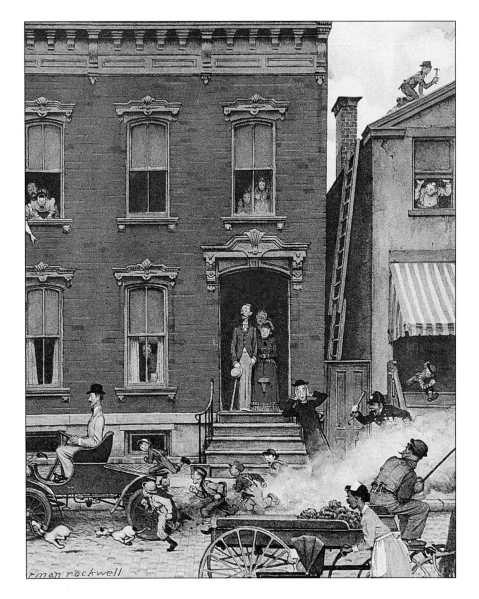

Girl With a Black Eye

Oil on canvas
34 × 30 inches (86 × 76cm)
1953

Although Mary Whalen's attire appears disheveled and her eye attests to a skirmish, she still seems fairly unruffled by the prospect of seeing the principal.

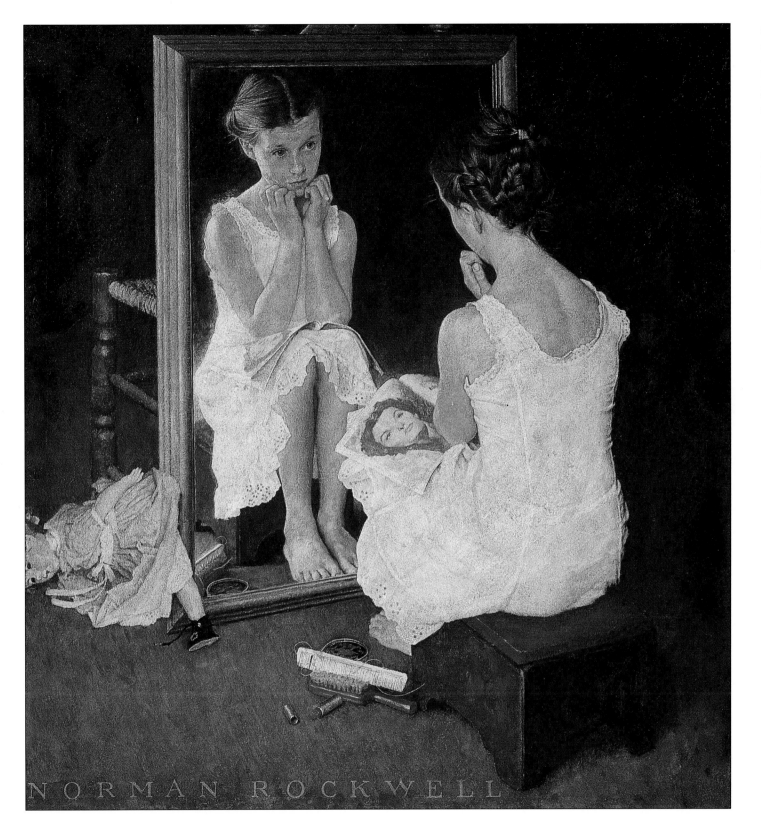

Girl at the Mirror
Oil on canvas
31.5 × 29.5 inches
(80 × 75cm)
1954

Norman Rockwell was a master at painting the joys, sorrows, and expectations of growing up. This scene is one with which most viewers can identify.

MASSACHUSETTS MUTUAL LIFE INSURANCE COMPANY

During the 1950s and early 1960s, a series of ads drawn by Norman Rockwell appeared for the Massachusetts Mutual Life Insurance Company. The eighty-one drawings all depict American family life during that decade, showing daily events as well as milestones. Rockwell even used himself as a model, facing a critical decision in the 1960 election.

Leaving the Hospital
Pencil on paper
13.5 × 10.875 inches (34 × 28cm)
1954

Father Feeding Infant
Pencil on paper
15 × 13.25 inches (38 × 34cm)
1957

Space Ship
Pencil on paper
21 × 13 inches (53 × 33cm)
1959–1960

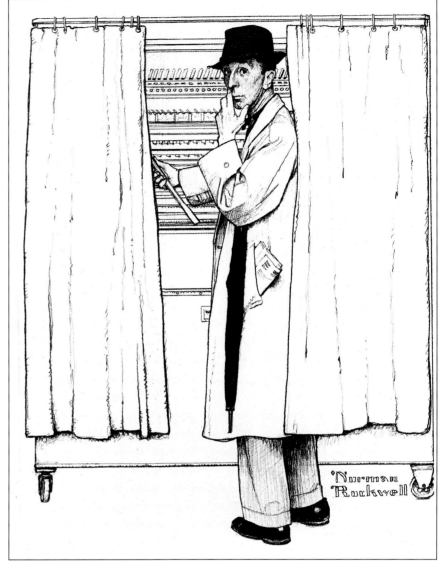

Norman Rockwell in a Voting Booth
Pencil on paper
13.25 × 10.25 inches (34 × 26cm)
1960

MAKING A PICTURE: ART CRITIC

Norman Rockwell's creative process is well documented in this series of preliminaries that lead to a completed *Post* cover. Getting the idea, making conceptual sketches, and arranging the modeling session were the preliminary steps. For *Art Critic*, Rockwell posed his wife, Mary. Next came preliminary studies in pencil and charcoal, and then studies in color. From these sketches, it is clear how Rockwell's initial concept of the woman in the painting changed over time. Lastly, Rockwell would surround himself with all his studies for reference and begin the final oil painting. The completed painting would then be rushed to the publisher for reproduction; in the case of *Art Critic*, it became a magazine cover.

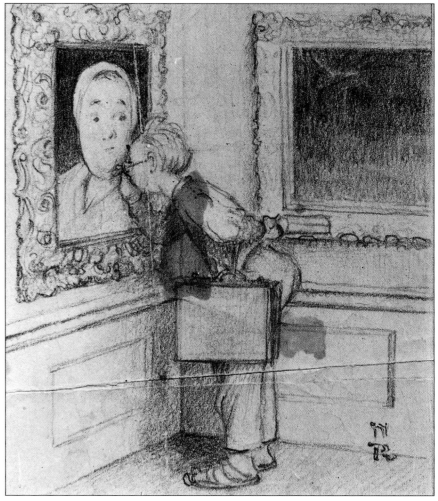

Conceptual Sketch
Pencil on paper
4.75 × 4.375 inches (12 × 11cm)
1955

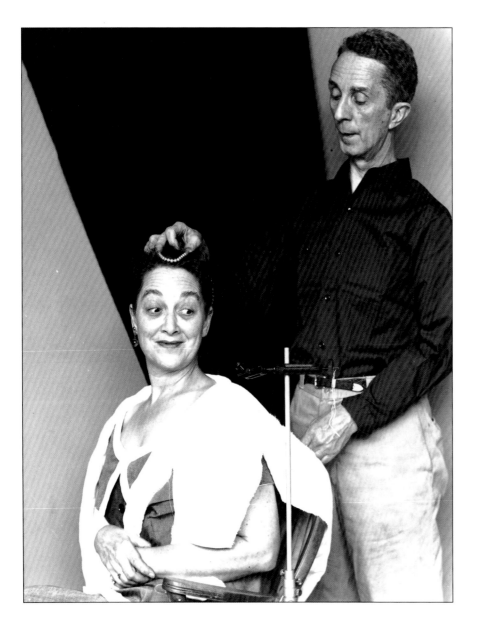

Norman Rockwell posing Mary Rockwell for Art Critic.

Preliminary Sketch
Pencil and charcoal on paper
11 × 7.5 inches
(28 × 19cm)
1955

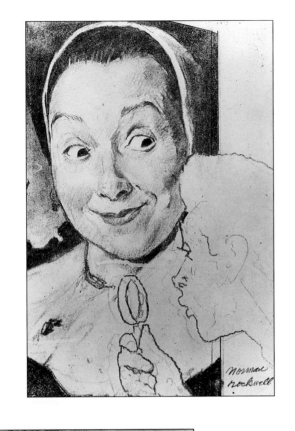

Preliminary Sketch
Charcoal and pen on board
11.375 × 8 inches
(29 × 20cm)
1955

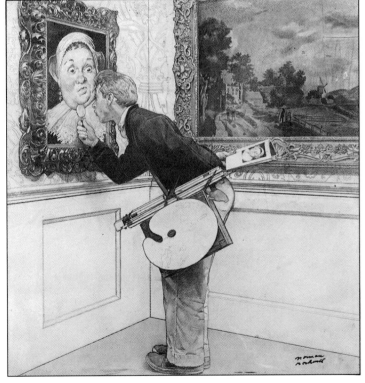

Preliminary Sketch
Charcoal on board
38 × 36 inches (97 × 91cm)
1955

Color Studies
Oil on acetate board
Left: 10.5 × 5.5 inches (27 × 14cm)
Center: 10.5 × 5.5 inches (27 × 14cm)
Right: 10.5 × 5.5 inches (27 × 14cm)
1955

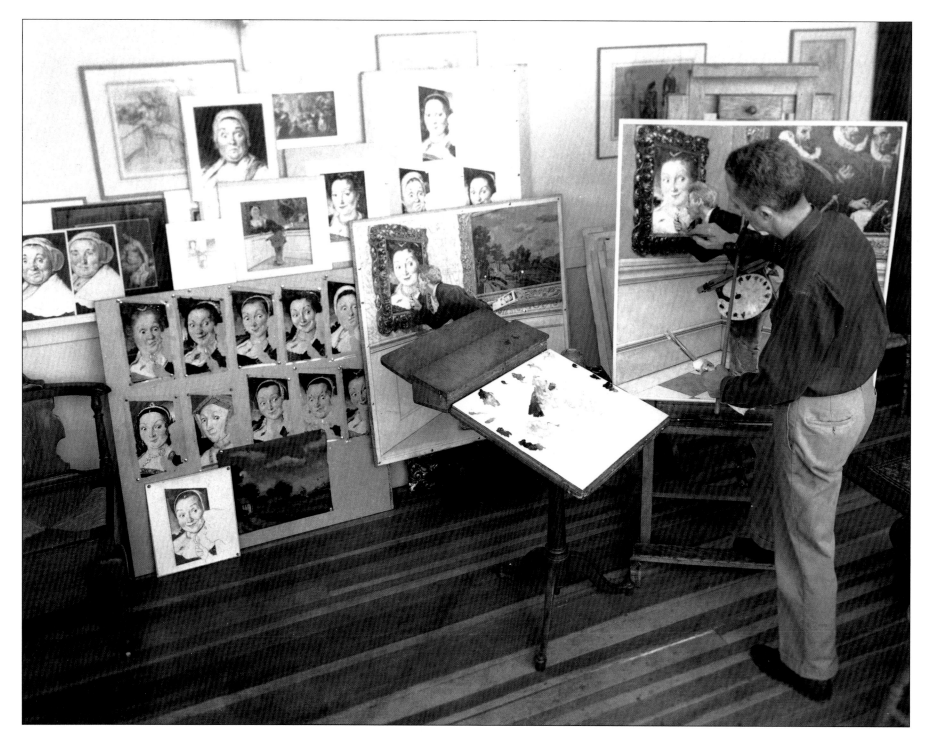

Norman Rockwell painting Art Critic.

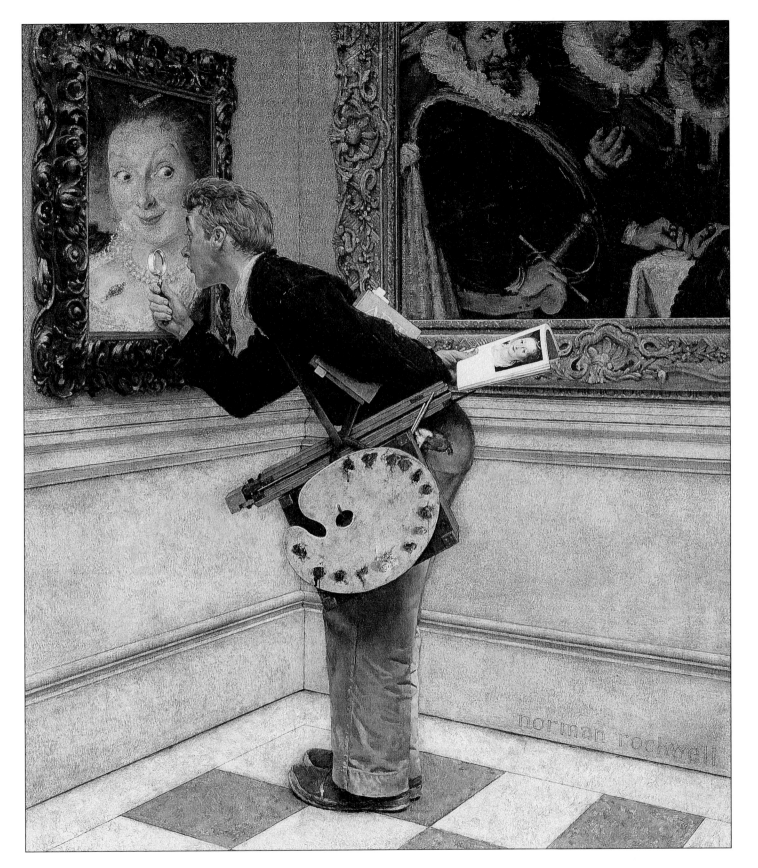

Marriage License

Oil on canvas
45.5 × 42.5 inches (116 × 108cm)
1955

The town clerk's day is nearly done—he's taken in the flag and donned his galoshes—and he's seen what's happening a thousand times. But the couple, awash in golden summer light, is oblivious to his indifference.

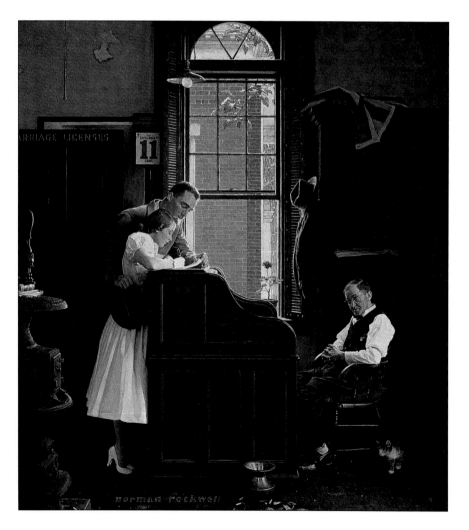

The Discovery

Oil on canvas
35.25 × 32.5 inches (90 × 83cm)
1956

This variation on the usual Christmas theme is Rockwell's classic glimpse of childhood disillusionment. A youngster discovers that Santa Claus is somewhere in the house—without his red suit.

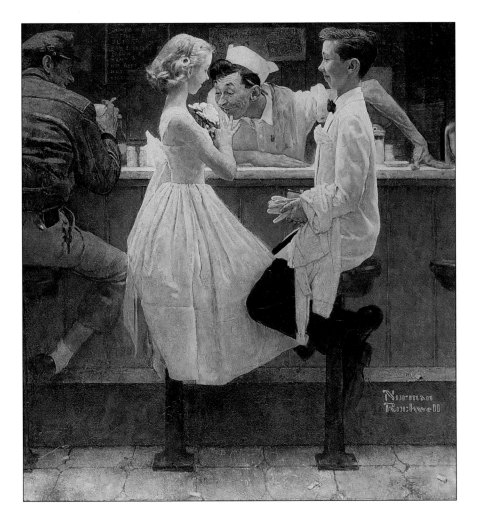

The Expense Account
Oil on canvas
31.25 × 29 inches (79 × 74cm)
1957

This *Post* cover was published with an expense account sheet as the background. The salesman's dilemma is readily apparent.

After the Prom
Oil on canvas
31 × 29 inches (79 × 74cm)
1957

Many of Rockwell's pictures take an affectionate look at diners, truck stops, cafeterias, and soda fountains. Here Rockwell combines his affinity for these places with another beloved theme—young love.

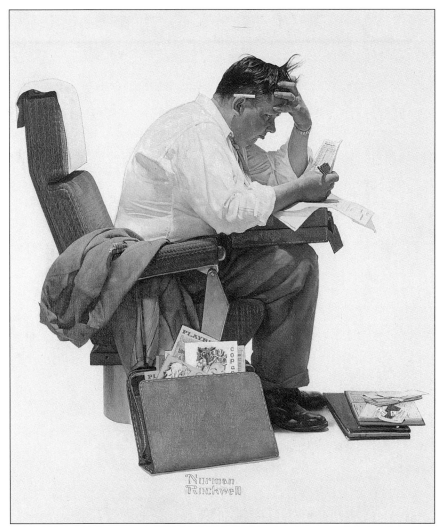

The Runaway

Oil on canvas
35.75 × 33.5 inches
(91 × 85cm)
1958

There is a timeless quality to the themes in Rockwell's work. Radios and coffeemakers may change from decade to decade, but little boys and their red bandana satchels will forever be tempted to wander down the road a piece looking for new friends and adventures.

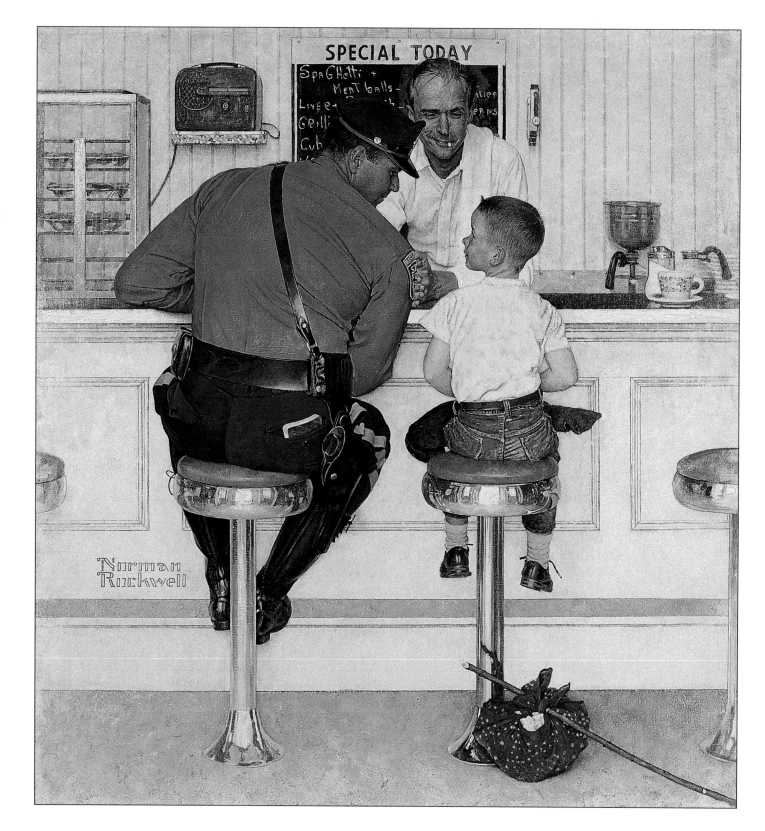

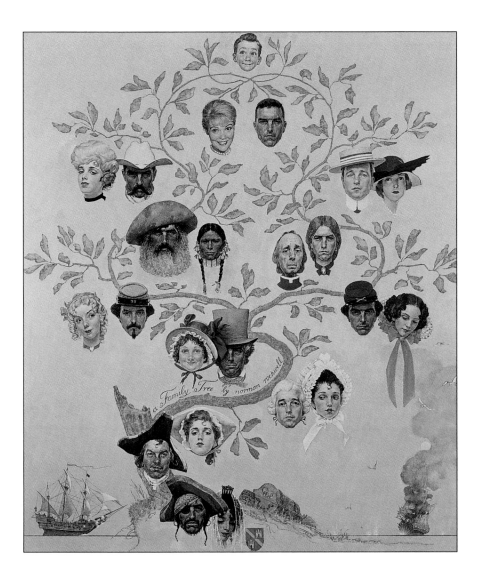

Family Tree
Oil on canvas
46 × 42 inches (117 × 107cm)
1959

Initially, Norman Rockwell drew the pirate at the beginning of this tree, then decided the family roots should be Puritan, but finally opted to return to the pirate. All the complex elements of an American's heritage are uniquely represented in this *Post* cover.

Portrait of Mary Barstow Rockwell
Charcoal on paper
14.6 × 11.6 inches (37 × 30cm)
c. 1959

This loving portrait of Mary, who died in 1959, was done for the frontispiece of *My Adventures as an Illustrator*. The book was dedicated to Mary, "whose loving help has meant so much to me."

Triple Self-Portrait

Oil on canvas
44.5 × 34.375 inches
(113 × 87cm)
1960

Here, Rockwell does away with the traditional head-and-shoulders self-portrait. He put himself in illustrious company—Durer, Rembrandt, Picasso, and van Gogh—artists he greatly admired and drew inspiration from.

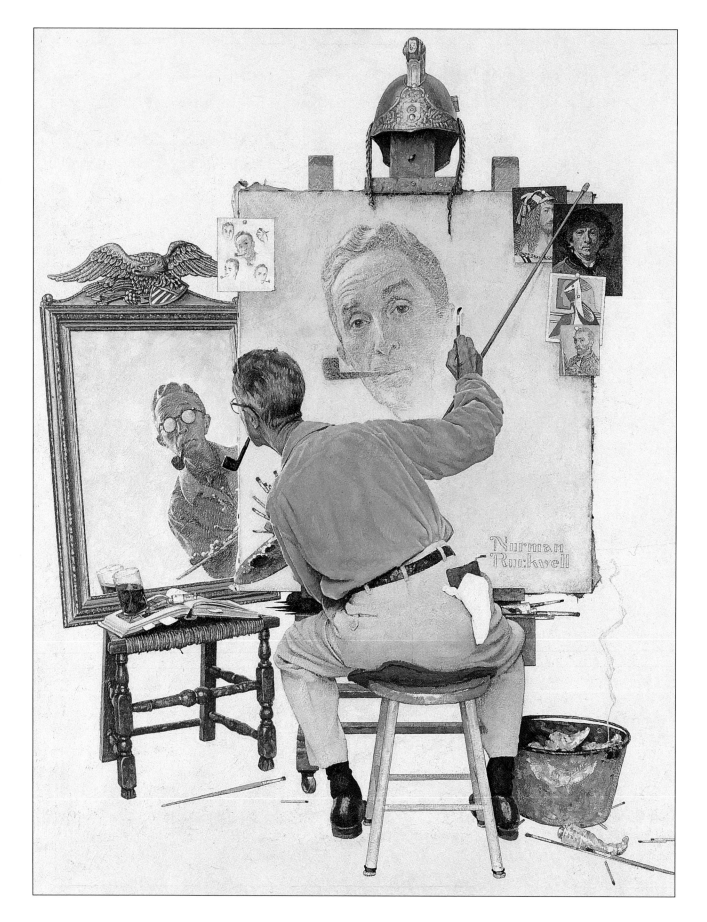

Triple Self-Portrait

Oil on canvas (study)
17 × 13 inches (43 × 33cm)
1959

The main purpose of color studies is to work out color issues, poses, and details for the final picture. Rockwell obviously made a few changes from this study for *Triple Self-Portrait*.

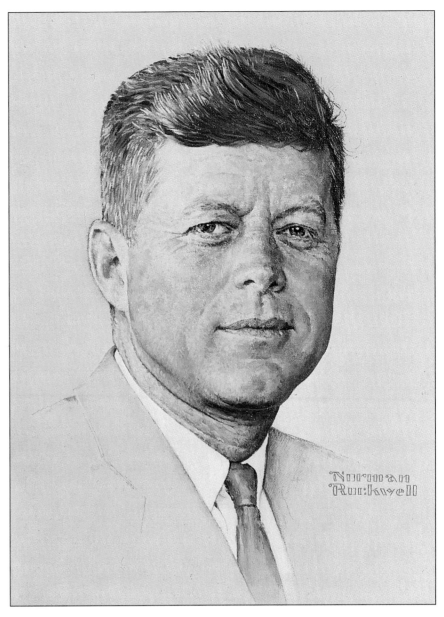

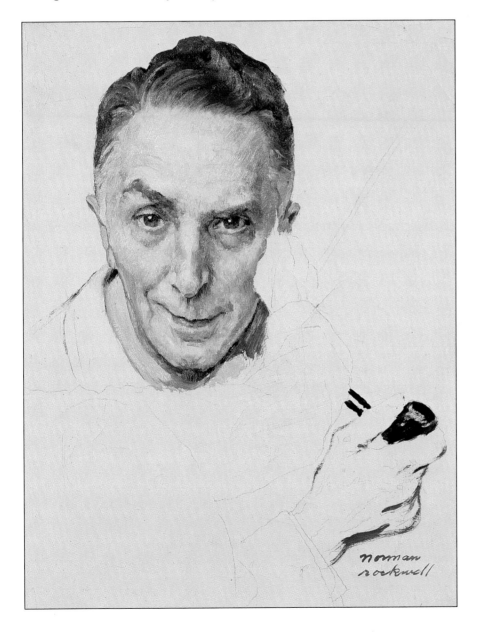

John F. Kennedy

Oil on canvas
16 × 12 inches (41 × 30cm)
1960

Rockwell once remarked that "painting candidates is like gilding lilies." For this portrait, Rockwell traveled to Hyannisport, Massachusetts. Except for the presidential candidates, Rockwell required that his portrait subjects pose at his studio in Stockbridge.

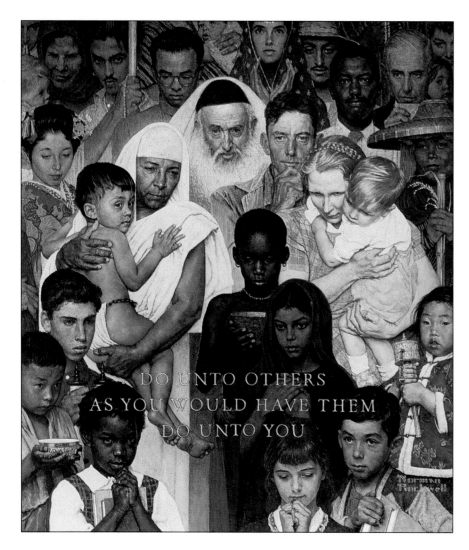

Golden Rule
Oil on canvas
44.5 × 39.5 inches (113 × 100cm)
1961

Since the ideas for cover illustrations came
directly from the illustrator himself, this painting
perhaps exemplifies Rockwell's philosophy of life
and his worldview.

Lubalin Redesigning
the *Post*
Oil on canvas
34 × 26.5 inches (86 × 67cm)
1961

During Rockwell's forty-seven-year career with
the *Post*, the design of the cover changed
several times. Here, Rockwell captures the
Post's newest look and also shows several past
cover designs.

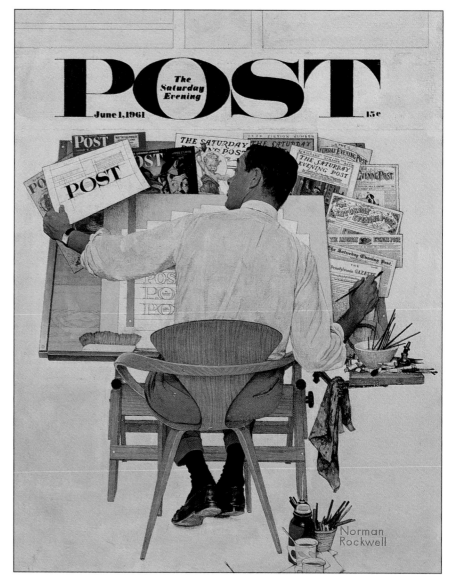

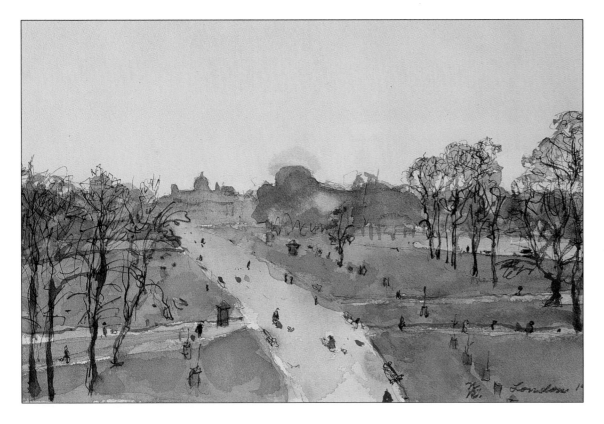

Across Kensington Gardens

Watercolor on paper
6.625 × 9.3 inches (17 × 24cm)
1961

In this travel sketch, another in his European travel series, Rockwell captured the serenity of one of London's most celebrated parks.

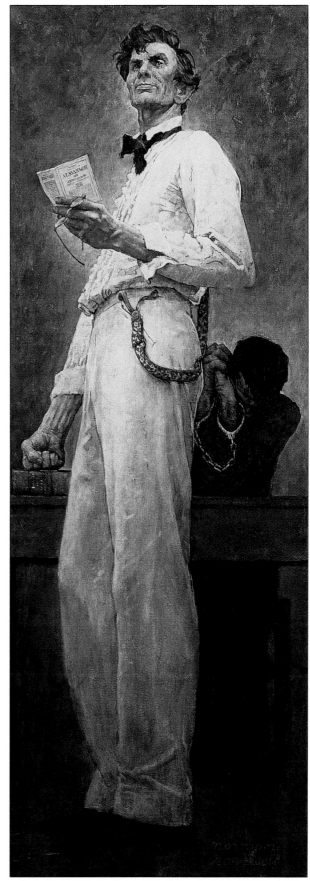

Lincoln for the Defense

Oil on canvas
49.75 × 17.5 inches (126 × 44cm)
1962

In this 1962 story illustration, a young Abraham Lincoln defends an alleged murderer in a case that heralded his career as a lawyer. Rockwell's use of perspective makes Lincoln seem almost a giant defending the oppressed.

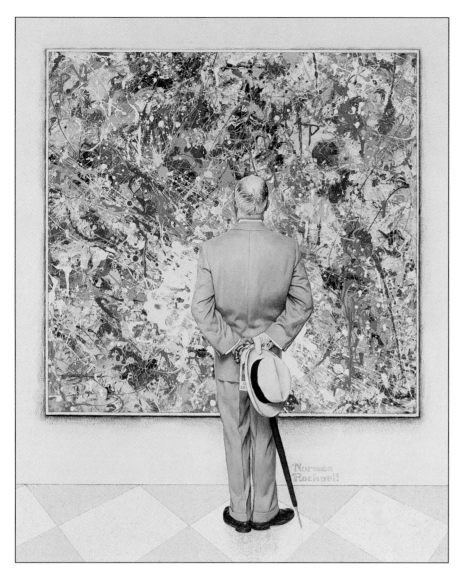

Portrait of Jack Benny
Oil on board
10.25 × 9 inches (26 × 23cm)
1963

By 1963, *The Saturday Evening Post* had changed its editorial focus. During his last year with the *Post,* Rockwell's covers were all portraits.

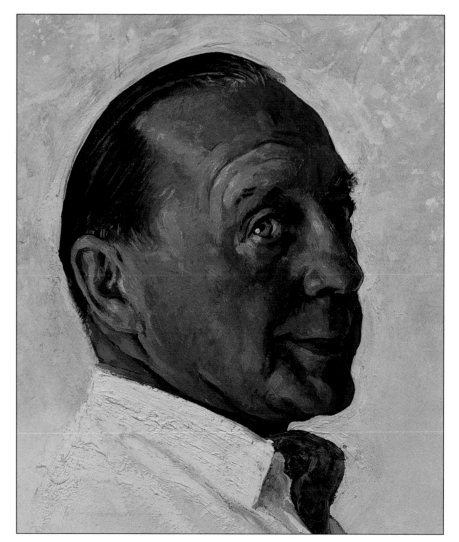

The Connoisseur
Oil on canvas mounted on board
37.75 × 31.5 inches (96 × 80cm)
1962

Although Rockwell's own work could be classified as realism, he also loved abstract art.

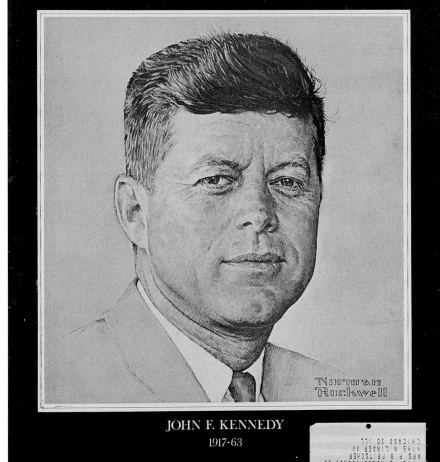

John F. Kennedy
14 December 1963

A dignified yet relaxed portrait, this *Saturday Evening Post* cover was used twice: once when JFK was running for president as a candidate in 1960 and again in 1963 after his assassination. This was Rockwell's last *Post* cover.

Portrait of a Russian Child
Oil on canvas
12 × 9 inches (30 × 23cm)
1964

Rockwell captured not only the places he visited during his travels, but also some of the wonderful faces he saw along the way. This charming portrait was done during a trip to the Soviet Union for the U.S. Information Society.

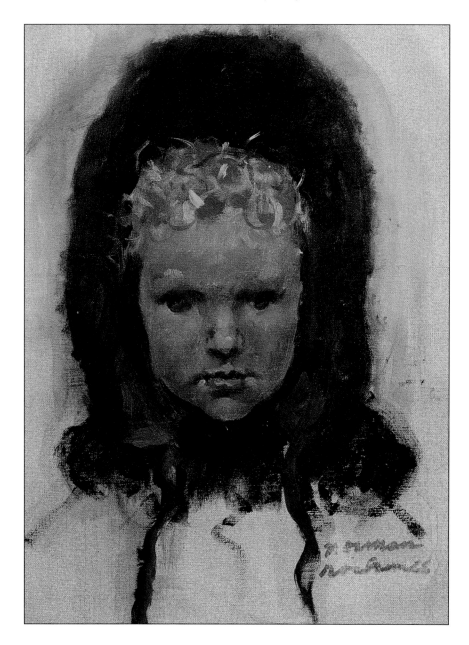

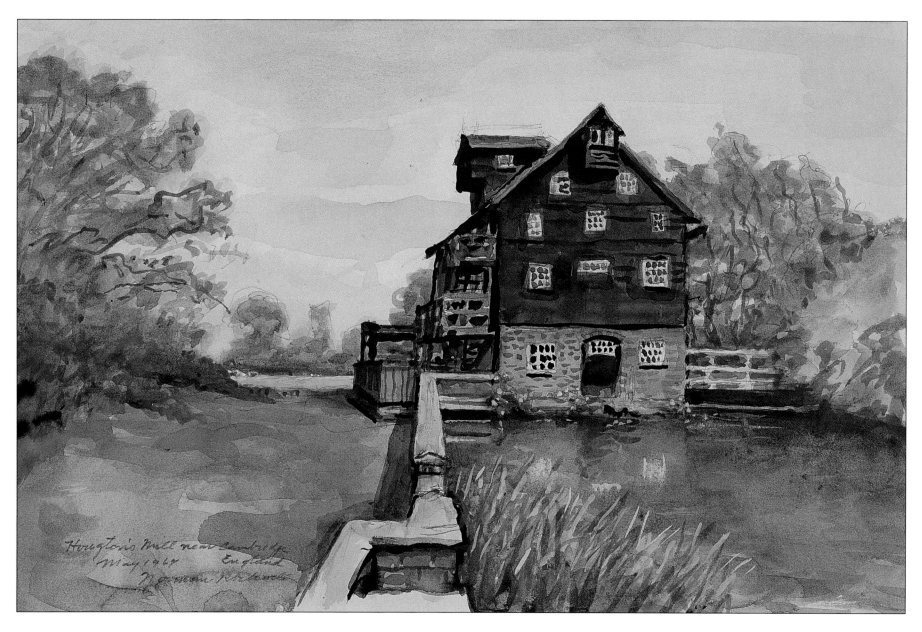

Houghton's Mill

Watercolor on paper
9.25 × 14 inches (23 × 36cm)
1964

Rockwell found this rustic scene in the countryside near Cambridge, England.
His travel sketches and portraits are much looser and more impressionistic than
his commissioned work.

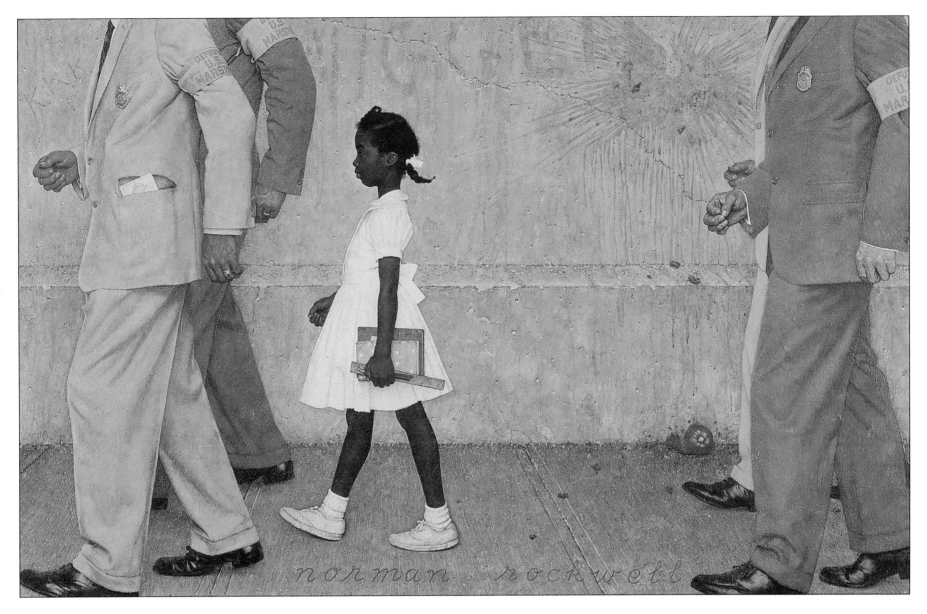

The Problem We All Live With
Oil on canvas
36 × 58 inches (91 × 147cm)
1964

Rockwell's illustrations for *Look* magazine covered the large events and important
issues of the day by examining the human element, as in this depiction of school
desegregation, his first work for *Look*.

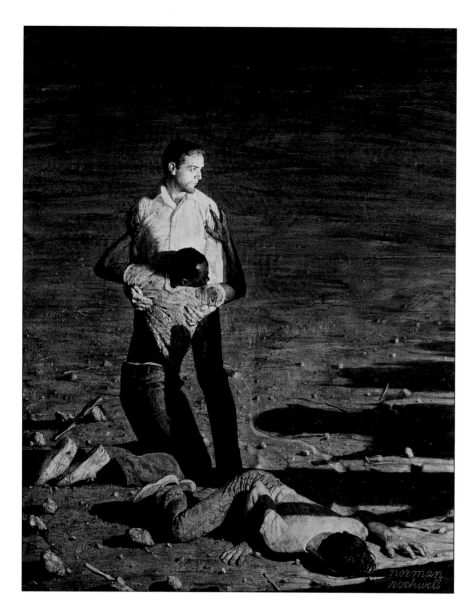

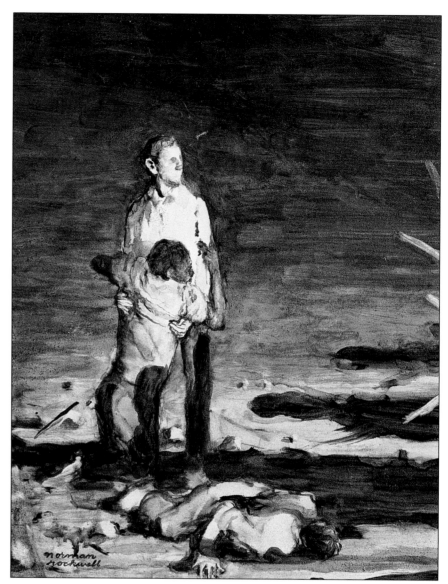

Southern Justice
Oil on canvas
53 × 42 inches (135 × 107cm)
1965

Look magazine commissioned Rockwell to
illustrate an article condemning violence against
blacks and other civil rights workers, including
three men murdered in Mississippi in 1964.

Southern Justice
Oil on board (study)
15 × 12.75 inches (38 × 32cm)
1965

In a rare occurrence, Rockwell's impressionistic
color study for *Southern Justice* was published
instead of the final painting. Both the *Look* editors
and Rockwell felt that the study more vividly
portrayed the emotional impact of the event.

Portrait of Norman and Molly Rockwell

Pencil on paper
14.1 × 11.3 inches (36 × 29cm)
1965

Norman met Molly Punderson, a retired schoolteacher, when he joined a poetry study group in the spring of 1961. Norman and Molly were married in October of that year.

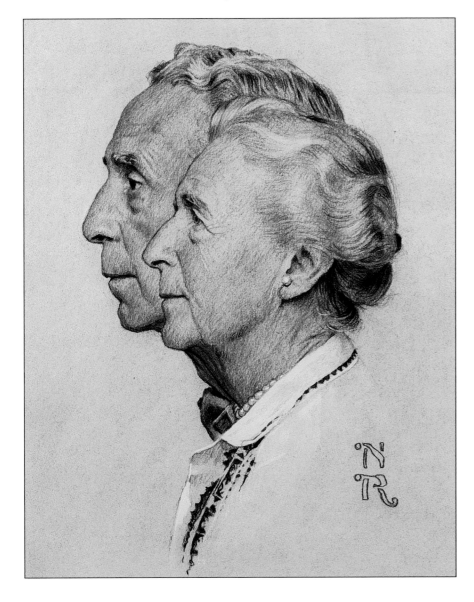

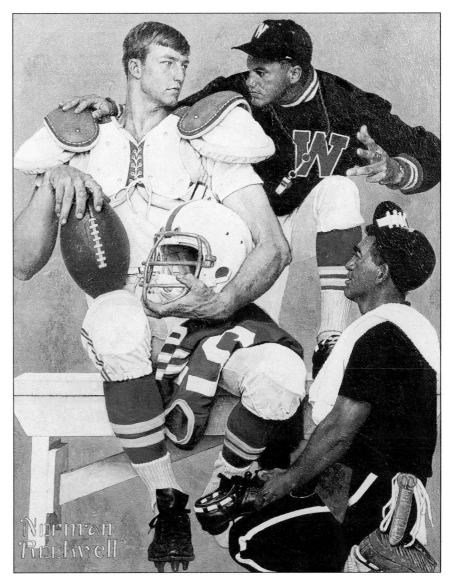

The Recruit

Oil on canvas
34.5 × 27.5 inches (88 × 70cm)
1966

Rockwell posed a player from the Williams College football team for this picture, using their school colors as well. As with that of Rosie the Riveter, the player's pose is taken from a work by Michelangelo; in this case, it was a statue of Guiliano de' Medici.

STAGECOACH

The following promotional portraits were part of a group done in 1966 by Rockwell for the Twentieth Century-Fox production of the motion picture *Stagecoach*. Rockwell went on location with the cast and crew of the movie to paint, but he also found himself playing the bit part of a silent film star called "Busted Flush" Rockwell.

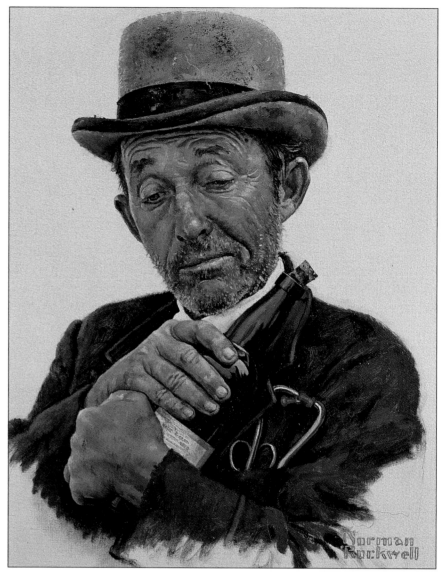

Ann-Margret
Oil on canvas
20 × 16 inches (51 × 41cm)
1966

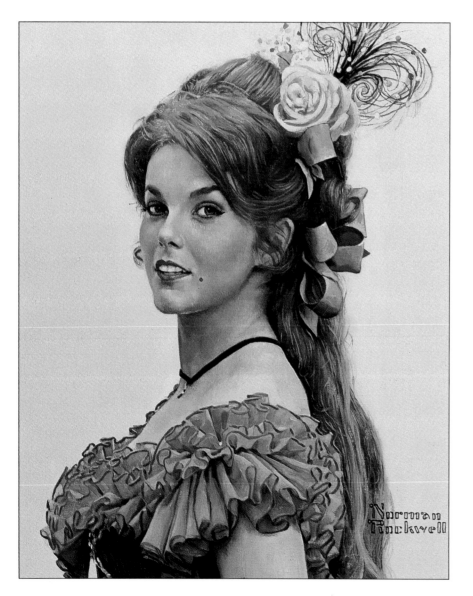

Bing Crosby
Oil on canvas
20 × 16 inches (51 × 41cm)
1966

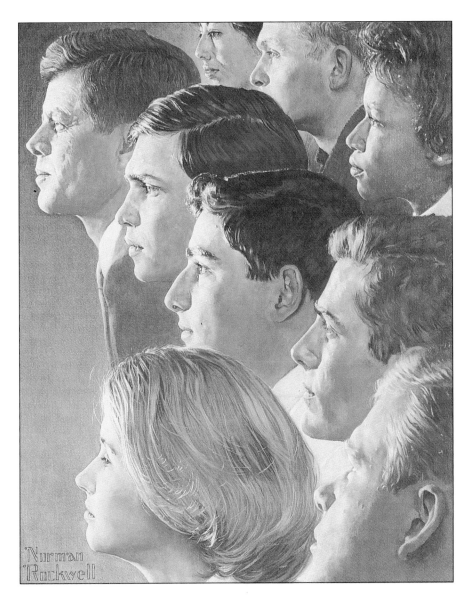

Peace Corps (JFK's Bold Legacy)
Oil on canvas
45.5 × 36.5 inches (116 × 93cm)
1966

In 1961, President Kennedy established the Peace Corps to foster understanding and peace between the United States and developing countries. This *Look* cover conveys the hope and promise of the young president's vision.

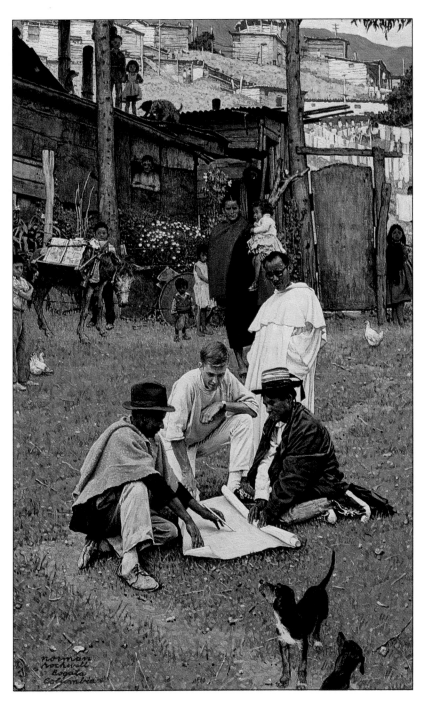

Peace Corps in Bogota, Colombia
Oil on canvas
20.75 × 12.75 inches (53 × 32cm)
1966

The Peace Corps series took Norman and Molly Rockwell on location to South America, Africa, and Asia, where they met with Peace Corps volunteers.

WILLIE WAS DIFFERENT

Norman collaborated with Molly to produce a children's book called *Willie Was Different*, published in 1967. Willie is an awkward wood thrush whose amazing musical talents bring him celebrity and attention, as well as a great aviary built just for him. But uncomfortable with his fame, and not able to perform in his new grand surroundings, Willie returns to the security of his home in Stockbridge.

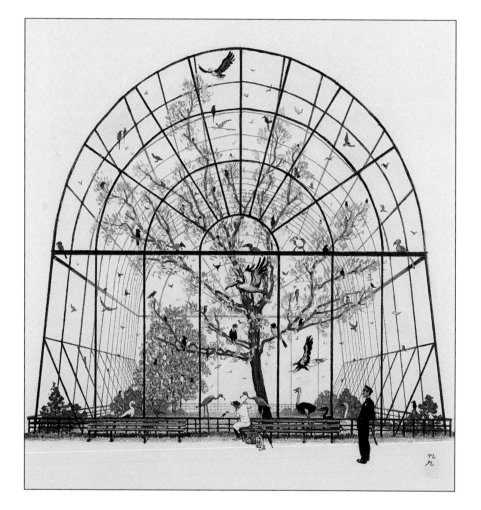

The Aviary
Oil
14 × 14.75 inches (36 × 37cm)
1967

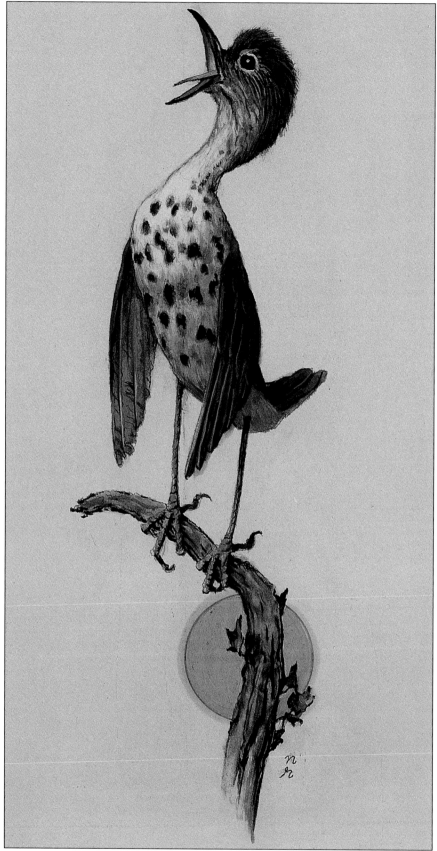

Willie the Thrush
Oil on board
16.5 × 9 inches (42 × 23cm)
1967

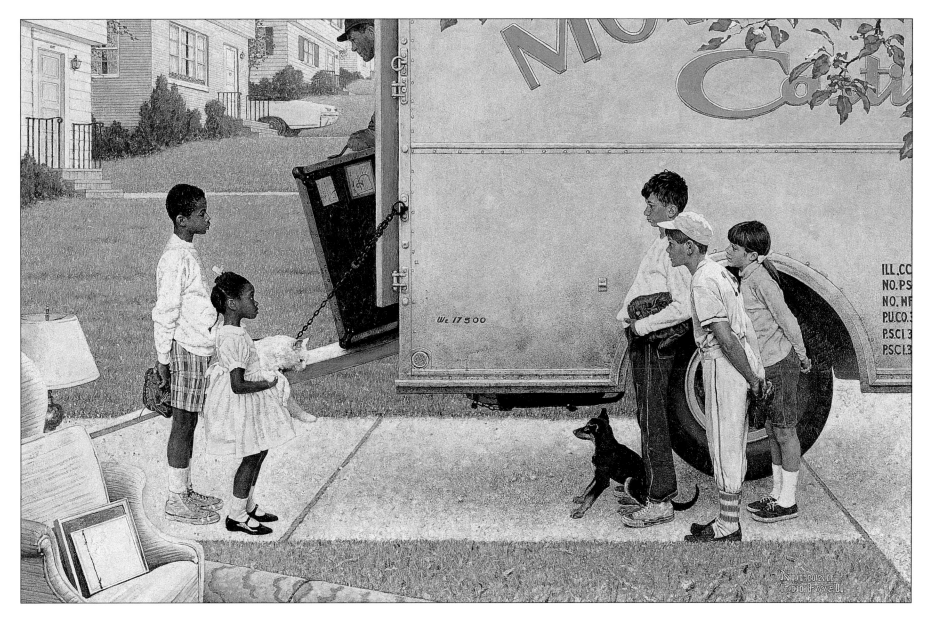

New Kids in the Neighborhood
Oil on canvas
36.5 × 57.5 inches (93 × 146cm)
1967

In his pictures depicting civil rights issues, such as this one for *Look*, as in his
other illustrations, Rockwell often focused on children and their role in the struggle.

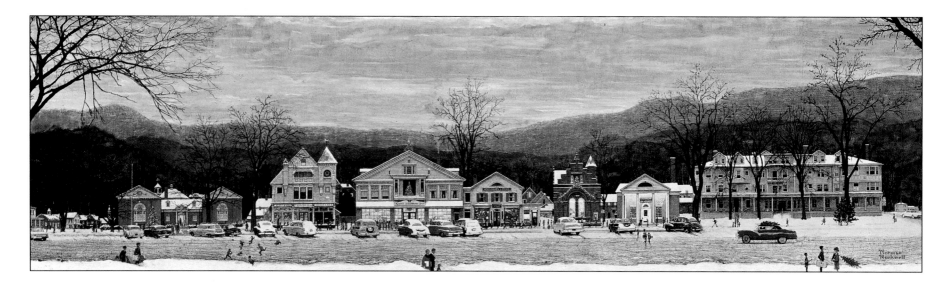

Stockbridge Main Street at Christmas
Oil on canvas
26.5 × 95.5 inches
(67 × 243cm)
1967

A loving portrait of his last hometown, Rockwell began this picture in the mid-1950s, completing it for *McCall's* magazine in 1967. "I just love Stockbridge. I mean, Stockbridge is the best of America, the best of New England."

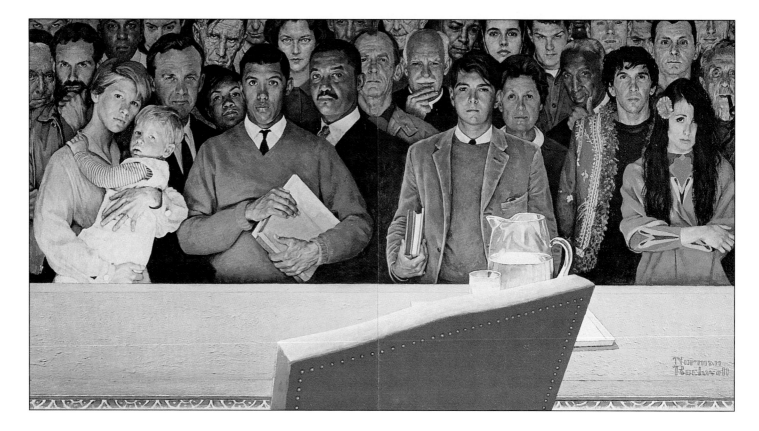

The Right to Know
Oil on canvas
29 × 54 inches (74 × 137cm)
1968

The massing of heads is a motif commonly used by Rockwell during the latter half of his career. In this story illustration for *Look*, Rockwell portrays the people in an honest, head-on manner. "We are the governed, remember," it says, "but we govern too."

Spring Flowers
Oil on canvas
30.375 × 25 inches (22 × 64cm)
1969

This picture can be considered a portrait of
Molly Rockwell, who was an avid gardener.
Molly's hat, gloves, sneakers, and the flowers
she has picked all appear; the impression is that
she herself could arrive at any moment.

Edinburgh Castle
Pencil on paper
8.75 × 13 inches (22 × 33cm)
1969

Rockwell recognized both the grace and
ruggedness of the ancient fortress town of
Edinburgh, and so he added this drawing to his
charming European sketchbook.

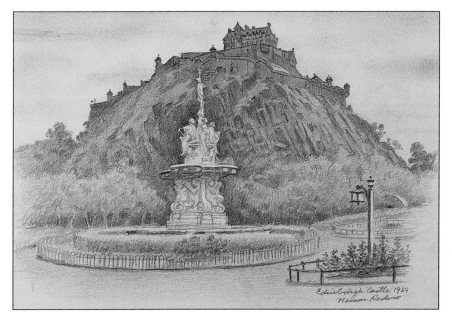

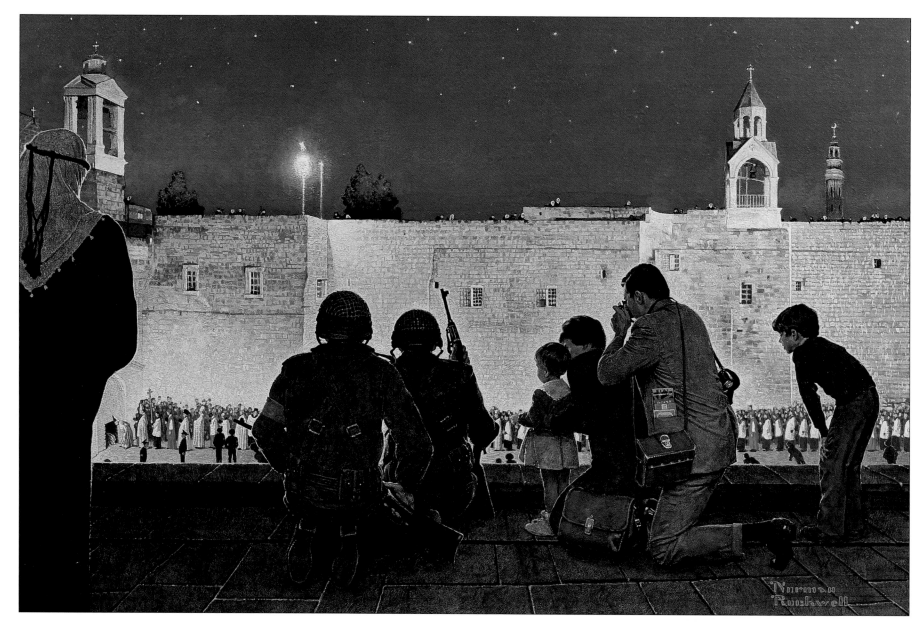

Christmas Eve in Bethlehem
Oil on canvas
33 × 51 inches (84 × 130cm)
1970

Rockwell spent Christmas Eve of 1969 in Bethlehem, a place of bitter tension
between religious groups. Rockwell thought that the view of the procession of
pilgrims juxtaposed with the reverential armed guards was a hopeful expression of
worldwide unity and peace.

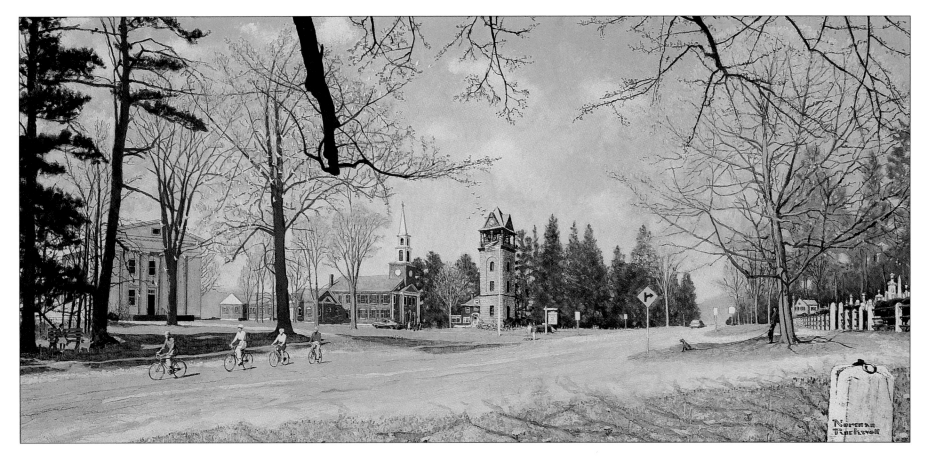

Springtime in Stockbridge
Oil on canvas
32 × 68 inches (81 × 173cm)
1971

Norman and Molly are seen with two friends on their daily bike ride through town in this picture done to celebrate "Norman Rockwell's Seventy-Eighth Spring." The style is very different from his earlier rendition of Stockbridge at Christmas that is shown on page 110.

Liberty Bell

Oil on canvas
45 × 33 inches
(114 × 84cm)
1976

In 1976, at the age of eighty-two, Rockwell created what was to be his last published illustration in celebration of America's bicentennial for the cover of *American Artist* magazine.

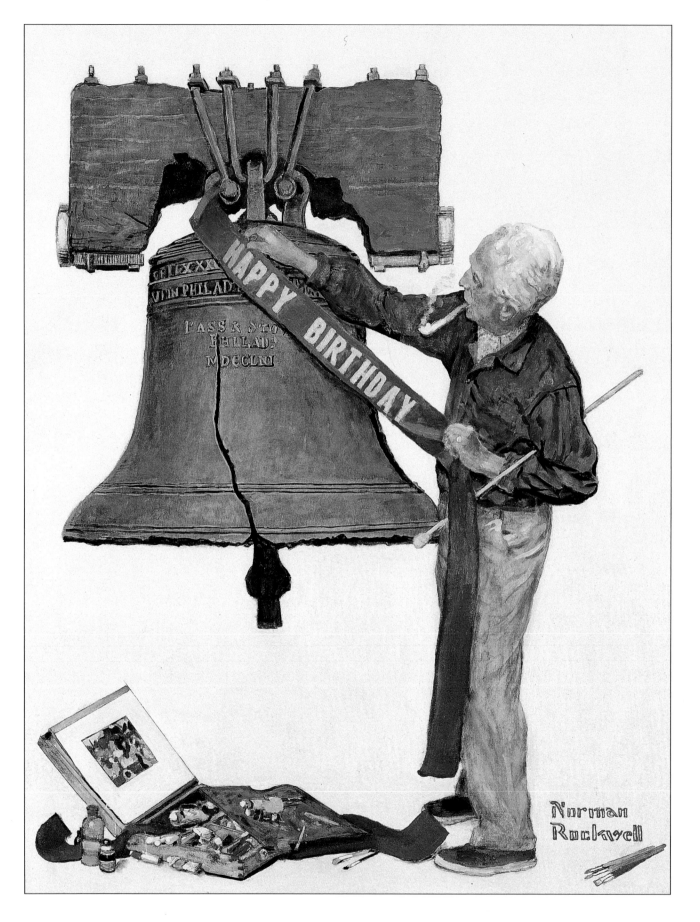

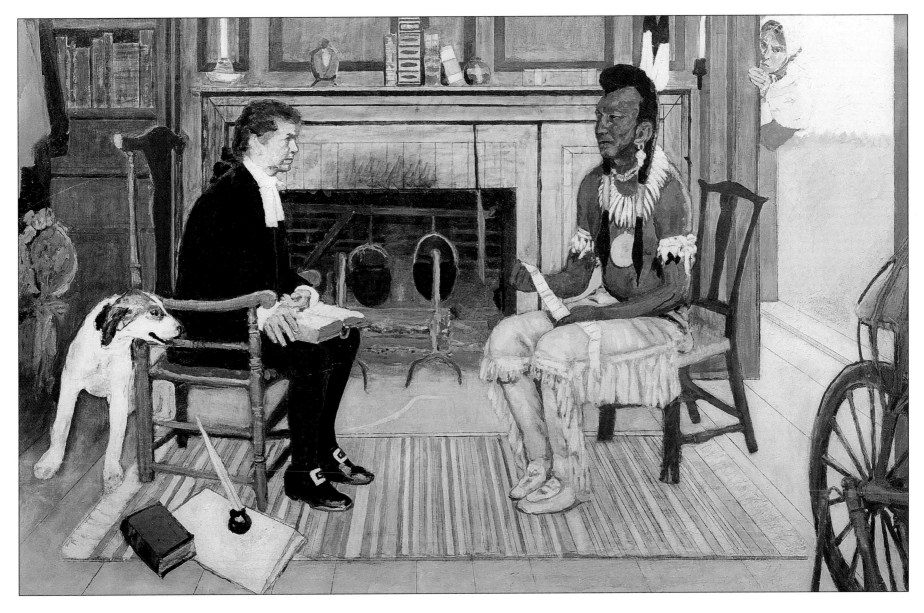

John Sergeant and Chief Konkapot

Oil on canvas
36 × 57 inches (91 × 145cm)
1972–1976

During Rockwell's six-decade career, he created between four thousand and five thousand pictures. This picture was on Rockwell's easel when he died on November 8, 1978, at the age of eighty-four.

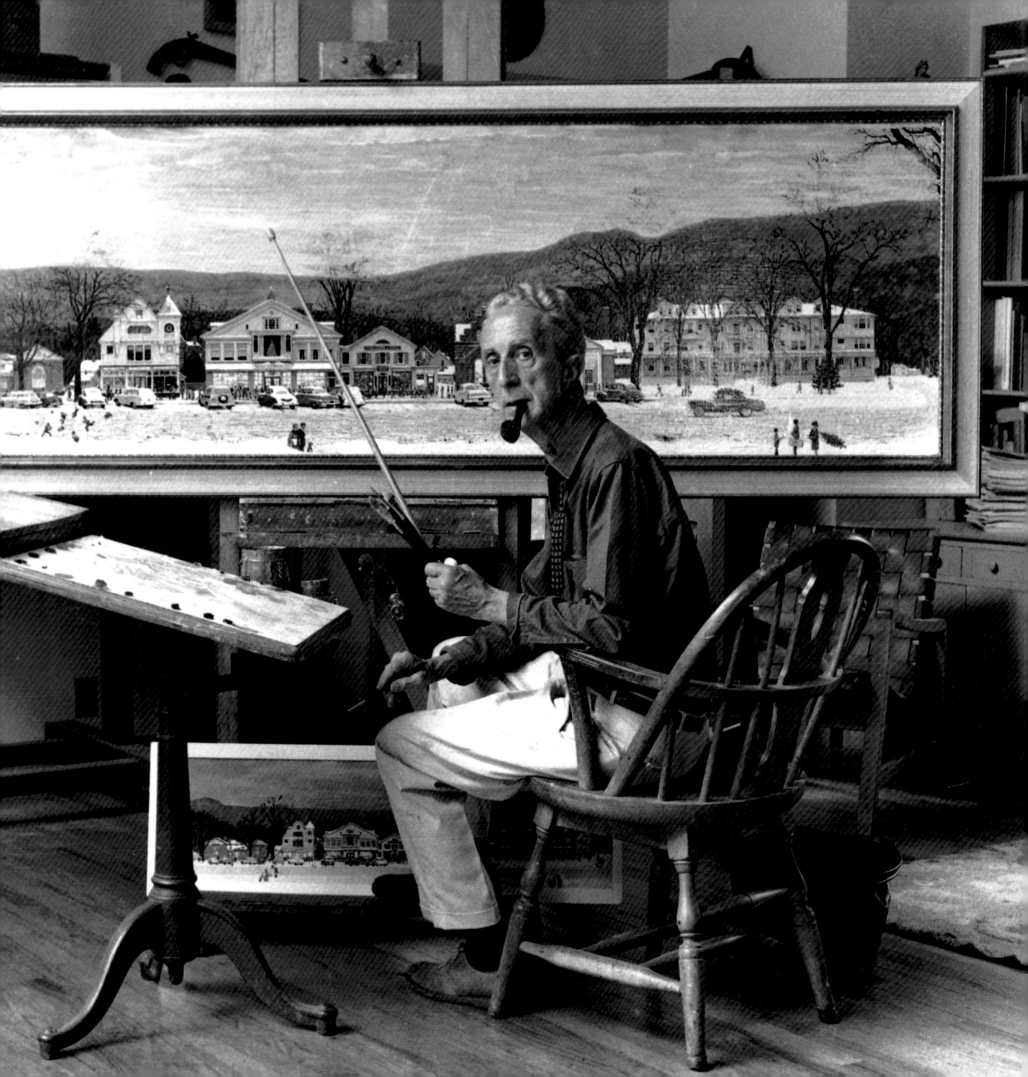

EPILOGUE:
THE NORMAN ROCKWELL
MUSEUM AT STOCKBRIDGE

The Norman Rockwell Museum at Stockbridge exhibits the largest significant public collection of artwork by Norman Rockwell. The museum's principal purpose is to collect, preserve, study, interpret, and present to the public material pertaining to the life and career of Norman Rockwell. The museum is also committed to interpreting the broader themes of Rockwell's contributions to illustration, American popular culture, and society.

The museum is the only one founded with the assistance of Norman Rockwell and personally endorsed by the artist, his family, and his estate. The nonprofit educational museum was started in response to the needs of Rockwell's local and national audiences, and literally, by popular demand. In 1967, a group of Stockbridge citizens (including Norman Rockwell and his wife) formed the Stockbridge Corner House Corporation and purchased The Old Corner House, a historic home that was threatened with demolition.

The Old Corner House opened to the public in 1969, and a historical collection from the town's public library was exhibited. Norman Rockwell and his wife, Molly, were members of the founding committee, and several

Opposite page: Norman Rockwell painting Stockbridge Main Street at Christmas, 1967. *Above: The new building housing the Norman Rockwell Museum at Stockbridge.*

of Norman Rockwell's paintings were displayed at the house. Gradually, and primarily through word of mouth, The Old Corner House became identified as a center for the exhibition of Rockwell's works.

In 1973, Rockwell entrusted his collection to the museum in order to ensure its continued exhibition and its proper care. Three years later, he added his studio and its contents to the trust. That same year, the museum began a ten-year research project that ultimately resulted in the 1986 publication of *Norman Rockwell: A Definitive Catalogue*, which contains more than 3,500 known images by Rockwell.

When the Norman Rockwell Museum completed its first year of operation, about 5,000 people had come through its doors. Today, more than 150,000 people visit the museum annually. To accommodate this tremendous growth, the museum moved into a new state-of-the-art museum building, located on a former estate in Stockbridge, in 1993. Norman Rockwell's studio and its contents, in keeping with his wish that his working environment be shared with the public, were moved to the site from Rockwell's home in the town center. The studio is now open to museum visitors seasonally.

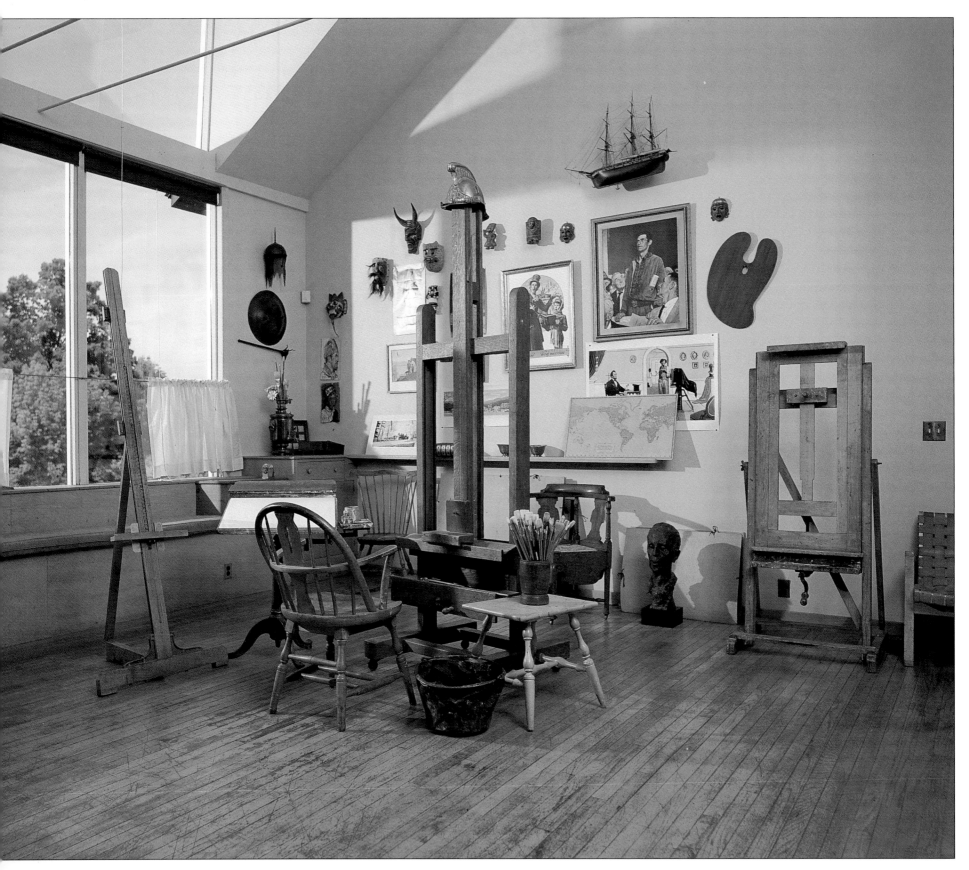

Norman Rockwell's Stockbridge studio.

COLLECTION CREDITS

Original works of art illustrated in this book that do not appear in the following list are in private collections.

The Norman Rockwell Museum at Stockbridge, Norman Rockwell Art Collection Trust: pages 14 (both), 22, 25 (left), 24, 30 (right), 35 (right), 42, 48 (right), 52 (both), 54, 61, 62, 63, 64, 72, 74 (left), 85, 88 (right), 89, 92 (both), 93 (right), 94, 95 (left), 96, 98 (both), 99 (right), 100 (right), 101 (right), 102, 104 (right), 105 (right), 106 (both), 107 (both), 108 (both), 109, 110 (top), 111 (both), 112, 113, 115

The Norman Rockwell Museum at Stockbridge: pages 23 (both), 25 (right), 26 (right), 28, 30 (left), 32 (right), 34, 35 (left), 36, 38 (left), 41, 43 (left), 44 (both), 49 (left), 53, 58 (bottom), 60 (top), 65 (left), 68 (left), 71, 73 (both), 74 (right), 82, 83 (right), 86 (both), 87 (right), 97 (right), 101 (left), 103, 104 (left), 114

Collection of The Uniroyal Inc.: page 26 (left)

Collection of General Electric Lighting Co., Cleveland: page 29 (right)

Collection of Mr. and Mrs. Henry B. Holt: page 31

Art from the Archives of Brown & Bigelow, Inc., and by permission of the Boy Scouts of America: pages 38 (right), 39 (both)

Collection of the Denver Museum of Western Art: page 46 (left)

Collection of the William A. Farnsworth Library and Art Museum: page 51 (left)

Berkshire Museum, Pittsfield: page 78

Collection of Williams High School Alumni Association on permanent loan to The Norman Rockwell Museum at Stockbridge: pages 80–81

Collection of Connecticut Valley Historical Museum; gift of Massachusetts Mutual Life Insurance Company: 86 (left)

Courtesy of Heritage Press, Norwalk, CT: pages 51 (left), 57 (right)

Christie's, Inc.: pages 27, 32 (left)

© 1992 Sotheby's, Inc.: page 29 (left)

Courtesy American Illustrators Gallery, New York: pages 46 (right), 50 (right)

PHOTOGRAPH CREDITS

All photographs are Courtesy of *The Norman Rockwell Museum at Stockbridge* except as noted by page number below.

McManus Studios, New York City: 1

Photo by Louie Lamone: 12, 15, 116

Photo by Brownie Harris, courtesy of General Electric: 118

Peter Aaron/Esto: 117

Bill Scovill, Photographer: 88, 90

INDEX